Pages 106 7
blank

# COUPLES

# COUPLES

*A Photographic Documentary*
*of Gay and Lesbian Relationships*

■

# JOHN GETTINGS

With an Afterword by Quentin Crisp

UNIVERSITY PRESS OF NEW ENGLAND

HANOVER AND LONDON

UNIVERSITY PRESS OF NEW ENGLAND

publishes books under its own imprint and is the publisher for

Brandeis University Press, Dartmouth College, Middlebury College Press, University of New Hampshire,

Tufts University, Wesleyan University Press, and Salzburg Seminar.

University Press of New England

Hanover, NH 03755

Printed in Singapore

5  4  3  2  1

ISBN: 0–87451–791–5

Library of Congress Catalog Card Number: 96–60789

# Acknowledgments

I am profoundly grateful to my mother and father, Mary and Brian, as well as my sister and brother, Andrea and Christopher. Without their love and encouragement, faith and unfaltering support, I would never have reached a point in my life and career where I could even have considered undertaking *Couples*. I regret that my father is not alive to see the final form of this work. I know he would have been proud.

I also wish to thank:

My grandmother Marie Morrison and my aunt and uncle, Geraldine and Andrew Morrison, for all that they have done for me. They are the kind of grandmother, aunt, and uncle you read about in storybooks.

Christina Reyna for her constant love and support over these last, and most difficult, years.

Yasmin Nissen for the security of having her hand in mine and for putting up with me for more years than anyone could expect.

I would especially like to thank Linda Burchill, one of my best friends and earliest supporters. Linda worked on this project with me since its inception. Without her assistance at every stage—from the first day of shooting through the proposal writing, the funding, the exhibition arrangements, and everything in between—this book would not have been possible.

I am deeply indebted to Quentin Crisp for his eloquent afterword for the book.

The staff at University Press of New England have my eternal gratitude for immediately recognizing the importance of the project, for their efforts to bring the book to the widest possible audience, and for their willingness to believe in me, by allowing me such broad, creative freedom.

I would also like to thank Kathy Gates for the original book design; Anthony Narcisso for his thorough transcription and editing, and his patience with me throughout the whole process; and Patrick Bernard for his assistance while shooting the project.

Thanks to Richard Williams and the generous contribution from The Polaroid Corporation, I have been able to continue my work.

For their friendship and help throughout the years, their generous contributions of time, knowledge and suggestions for the book, I am especially grateful to Bonnie Bee, Robert Castro, Maria Grazia Cavenaghi, Marco Consonni, Rafael Fagundo, Alessia Falletti, Rebecca Friendly, Ian Gittler, Nina Graybill, Chen Ho, Marzana Kosicka, Kito Mbiango, Susan McCarthy, Jessica Mezyk, Heidi Niemala, Miranda Ostini, Andrea Pacella, Grant Perigo, John Rago, Kerry Reardon, Suza Scalora, J. C. Suarez, and Paulo and all of his family at Auriga.

I would like to thank all of the couples who contributed to the project by sharing such intimate parts of their lives. I would also like to thank those who participated but, because of editing or by their own choice, did not appear in the book.

For just plain blindfaith, I would like to thank Mahmoud Mustafa, M.D., and Fredrick Finelli, M.D. Their patronage early on helped me pay the rent and continue with the project.

Finally, for his friendship and because he was the inspiration for this book, Juan Carlos has my most sincere thanks.

This book is dedicated to the memory of my dad, Brian Gettings.

# Introduction

Many people ask me how *Couples* came about. I can trace the idea for *Couples* back to a day in April 1993 when I was walking with my girlfriend in Milan, Italy. The sidewalks were crowded with people and the streets jammed with the usual traffic. As we walked, I began to notice that just prior to crossing a street our hands would come together naturally and unconsciously, and I began to think of how comforting and secure it felt having her hand in mine. I had never really thought about this before. If my friend Juan Carlos had not been with us that day, I probably would have continued to take small but special moments like that for granted. Juan's presence forced me to open my eyes.

Juan is gay and out of the closet. But during the years I had known him, I had never seen him holding hands with his boyfriend, as holding hands was something he reserved for a gay club or in private. It was the same with most of my other gay and lesbian friends. I had never stopped to consider how difficult it must be for them, having something so innocent, yet so meaningful, denied just because they are gay. Until that moment, I had considered myself aware and sympathetic to gay rights. Up until then, I had not appreciated the extent of the struggles gays and lesbians deal with every day in a society that has made even the simplest display of affection between gay couples, something as small as holding hands, a statement rather than a simple expression of feeling.

I decided then to develop a project that would recognize the bonds between homosexual couples and that, hopefully, would have the same eye-opening effect on others that I had experienced. The project took shape a year later in New York when I decided to use portraits of gay and lesbian couples to counter the stereotypical and often negative portrayal of gays and lesbians routinely seen in the media—images that feed and perpetuate prejudice, images that keep Juan Carlos and his boyfriend from holding hands in public.

A photographer has a unique role. He or she can use the camera to deceive or distort, to present a point of view, or as a witness revealing the truth. In shooting *Couples*, I chose to take a purely documentary approach. Rather than choose subjects, I wanted to create a blind study where I would be the tool that would record the images of gay and lesbian couples in the 1990s. I was surprised that although there had been other photographic books on gays and lesbians, an unbiased portrait study of couples had not yet been done.

The opportunity to take the portraits came on June 26, 1994, at the rally in New York City on the final day of a week-long celebration commemorating the twentyfifth anniversary of the Stonewall riots and Gay Pride week. It was in Central Park, at the site of the rally, that two assistants and I set up a backdrop, diffusion scrim, and my cameras. We had erected a daylight studio in the middle of thousands of potential subjects.

To achieve the random selection required, my assistants and I posted handbills around the park stating, "Looking for Couples for My Book Project." I was able to attract a very large number of couples to photograph. We did not approach a single person, and I photographed everyone who volunteered. We worked from nine in the morning until sundown, during which time I shot 124 couples, many of whom had just finished a long march up Fifth Avenue on a very hot day.

I wanted to keep the same hands-off approach in the actual shoot and gave almost no direction for each sitting. I told each couple to just be themselves in front of the camera and to pose as they liked. I then waited for the right moment to make the exposure. Using Polaroid 665 Positive/Negative film, I made two (in one case three) exposures of each couple.

Of the 124 couples I photographed that day, I have edited the contents of the book down to 84 portraits. My edits were made solely for technical reasons. In the months that followed, I realized that details about the couples' lives would add to the impact of the photos, for there was much more to know about each couple than a photographic portrait could reveal. In keeping with my documentary approach, I asked each couple to provide biographical information and to make a statement about themselves and their relationship. Their responses compliment the portraits to make *Couples* a broad overview of the personalities that make up the gay and lesbian community.

*April 1996*                                             J.G.

# COUPLES

# Patrick Bryan Lee & Leonard Earl Lewis

## FOUR YEARS TOGETHER

***How We Met*** ❡ BRYAN: I was introduced to Leonard at Frank's Place, New London's oldest gay bar. We were several feet away, looking at each other and smiling. I remember Leonard's broad smile. At that moment a friend got a little daring and shoved his hand down my open shirt to touch my chest hairs. Leonard dropped the glass he was holding. Glass shattered everywhere. It would be another two months before we reintroduced ourselves. When we did, we spent that first extended evening in conversation. I was wearing a T-shirt that said, "An Evening With Elvis Costello" and Leonard's opening line was, "I'd like to spend an evening with Elvis Costello." To which I replied, "That can be arranged." Three months later, in front of the Liberty Bell in Philadelphia, he formally asked me to be his lover. I was moved to tears. I loved this man, but the idea of a union proposal had not crossed my mind. I have never known such devotion and love. To this day there is a park bench across from the Liberty Bell with our initials carved in it and every year we try to get back to Philly to see it.

***Coming Out*** ❡ BRYAN: Coming out gave me an inner peace I had never known before. ❡ LEONARD: It made me aware of prejudgment.

***Statement*** ❡ LEONARD: My life, my love, my friend. Three things that best describe my partner, Bryan. Without him my life would not have the same wholeness that it now does. I realize that a vital part of love is of yourself. My lover has not only made it a joy, he has indeed made it a pleasure. My lover is patient, loyal, supportive, compassionate and admirable. ❡ My friend, from beginning to end, we were friends first in search of joy together. We lowered our defenses, opened our hearts, and we know love forever.

***How We Spend Our Free Time*** ❡ We spend our time in search of the right blend of house and acid-house music. We travel almost every weekend to dance clubs in New York, Boston, Providence, Hartford, New Haven, and New London. We have a house and two dogs, and when we aren't out dancing we enjoy our family and gay friends.

## BRYAN

**BORN:** *March 26, 1963, Socorro, New Mexico* **RESIDENCE:** *New London, Connecticut* **EDUCATION:** *B.S., Communications, St. Cloud State University* **OCCUPATION:** *Broadcasting* **WHEN OUT:** *1985 to myself; 1991 to my family*

## LEONARD

**BORN:** *January 28, 1959, Philadelphia, Pennsylvania* **RESIDENCE:** *New London, Connecticut* **EDUCATION:** *Wilford Academy of Cosmetology, Pennsylvania Institute of Technology, U.S. Navy (honorable discharge 1978)* **OCCUPATION:** *Bottling-company technician* **WHEN OUT:** *1976*

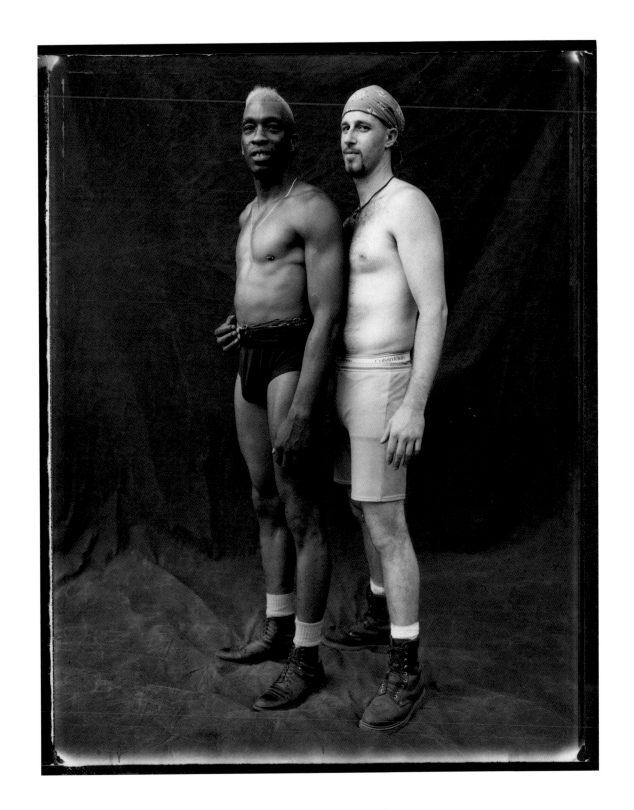

# Kevin S. Smith & Sal Taschetta

## SIX YEARS TOGETHER (ON AND OFF)

***How We Met*** ❡ SAL: Kevin and I met in Boston at a birthday party for other friends who were born in April. It took a few months for us to get together. I didn't think Kevin was interested but he kept pursuing me until I got the hint. ❡ After we met we were together for one year, but Kevin had signed up for the Peace Corps and was given a four-year assignment. We wrote frequently and I moved to New York. When he returned to the U.S., he came to visit me and ended up moving in with me.

***Coming Out*** ❡ KEVIN: There was never one point in time when I came out. In fact, I am still in the process. I had always known that I was homosexual, but there were few options for me to discuss it in the suburban Midwest, where "homosexual" was a forbidden word. I am an extremely private person and find it frustrating to be forced to reveal such a personal matter to others, something heterosexuals never have to do. Yet if one doesn't discuss it openly, it can become a barrier to relationships. However, now that I have found a lifelong partner in Sal, I find it easier to talk about because I want to share my life—our life—with others. ❡ SAL: When I was a freshman in college I finally figured things out and acted upon it. It's not that big a deal in art school. We were all hanging out with a gay club crowd anyway. We liked the music better and our straight female friends could go out for a good time and not be harassed by guys—although they always seemed to meet someone. I did loose some acquaintance-type friends but made many more while strengthening the good friendships I had already. ❡ I was outed by my older sister when I was in college. I had bleached my hair blond that summer and my sister put two and two together and decided to call our mother without telling me. My mother didn't take it very well. Eventually she was OK with it, as OK as she could be. I wish I had told them to just deal with it. Kids today are so bold and righteous. I love that. They know who they are, and they're right in your face! ❡ My father asked me recently. He said that it didn't matter to him, but that he felt religion has a problem with gays because they need people to procreate to expand their following, as well as their cash flow. ❡ I've never had a problem at work. I am in an industry that has been heavily exposed to gays. It's commonplace. ❡ As far as religion is concerned I don't believe in organized religions and they don't believe in me.

***How We Spend Our Free Time*** ❡ We spend most of our free time taking long walks exploring the city.

### KEVIN

**BORN:** *April 26, 1962, Pontiac, Michigan* **RESIDENCE:** *New York City* **EDUCATION:** *B.S., Management, University of Massachusetts, currently pursuing M.S., Nonprofit Management* **OCCUPATION:** *Assistant director*

### SAL

**BORN:** *April 1, 1964, Boston, Massachusetts* **RESIDENCE:** *New York, New York* **EDUCATION:** *B.F.A., Massachusetts College of Art* **OCCUPATION:** *Design coordinator*

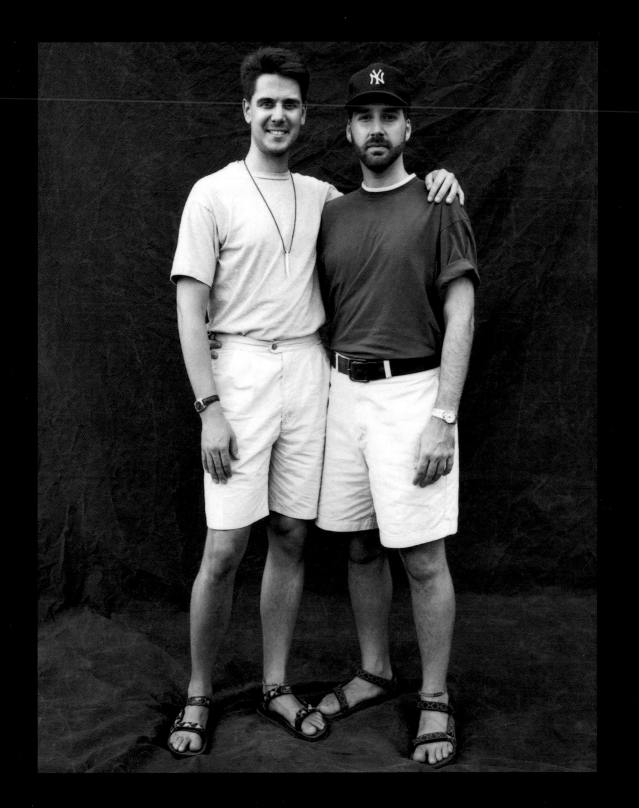

# Robert Jones, Jr. & David Stohrer

## ELEVEN MONTHS TOGETHER

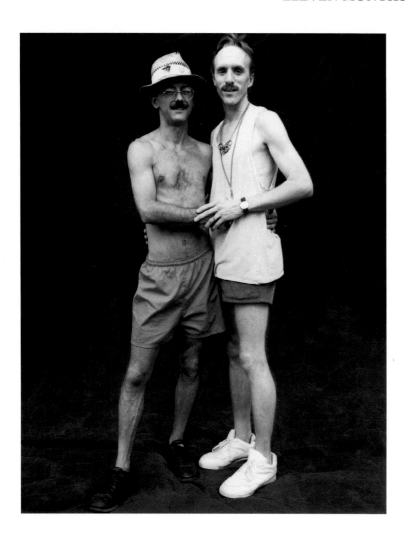

**How We Met** ❡ At an AlAnon meeting. ❡ We've been together eleven months. A bonding ceremony is to take place in May 1995.

**Coming Out** ❡ DAVID: It brought me a lot closer to my parents and family. My parents are more supportive of my life-style. They love Rob. I'm much more able to accept myself more openly and I'm much happier. I'm also open and out at work. ❡ ROB: There was very little effect. Everyone seems very accepting.

**How We Spend Our Free Time** ❡ DAVID: We live an hour away from each other so free time together is at a premium. We like to go to the movies, bowl, and have romantic dinners. We like camping and country dancing. Best of all, we take walks hand in hand, kissing and telling each other how much we love each other. ❡ ROB: Country dancing, bowling, reading, and movies.

### ROBERT

**BORN:** *May 2, 1959, Shamokin, Pennsylvania*   **RESIDENCE:** *Coatesville, Pennsylvania*   **EDUCATION:** *High school*   **OCCUPATION:** *Convenience store manager*
**WHEN OUT:** *1981*

### DAVID

**BORN:** *June 29, 1961, Camden, New Jersey*   **RESIDENCE:** *Oaklyn, New Jersey*   **EDUCATION:** *High school*   **OCCUPATION:** *Bookkeeper*   **WHEN OUT:** *Age eighteen*

# Kathleen Abbondanzo & Corrine Stoewsand

## FOUR YEARS TOGETHER (ON AND OFF)

*How We Met* ❡ We met at a women's bar.

*Coming Out* ❡ CORRINE: Coming out is a life-long process. I have to "come out" to straight people and say that I'm in a lesbian relationship. To gay people I have to "come out" and say that I am bisexual, and that I have had relationships with men in the past and would consider it a possibility in the future (if anything happened between Kathy and me).

*How We Spend Our Free Time* ❡ KATHLEEN: Running and visiting friends. ❡ CORRINE: Swimming, bicycling, and gardening.

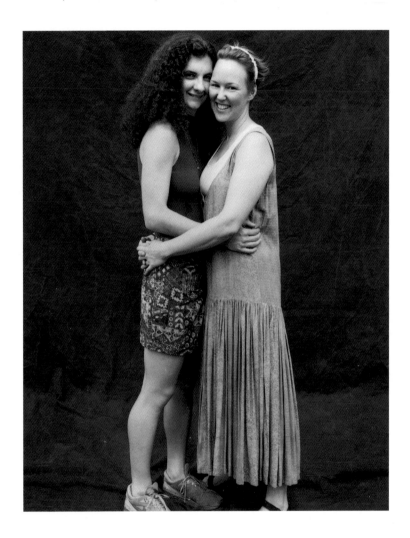

### KATHLEEN
**BORN:** *January 26, 1963, Morristown, New Jersey*   **RESIDENCE:** *New York, New York*   **EDUCATION:** *B.S., Computer Science*   **OCCUPATION:** *Computer programmer*

### CORRINE
**BORN:** *July 14, 1960, Ithaca, New York*   **RESIDENCE:** *New York, New York*   **EDUCATION:** *Ph.D., Urban Planning*   **OCCUPATION:** *Consultant*

# Cole Benson & Tom Ramirez

## EIGHT YEARS TOGETHER

*How We Met* ¶ We moved in the same social circles, and met in a bar.

*What Effect* ¶ COLE: I could relax.

*How We Spend Our Free Time* ¶ We enjoy movies, theater, sports, socializing with friends, and camping.

*Addendum* ¶ TOM: Since the photograph was taken I've been diagnosed with HIV. Being disabled with HIV has allowed me to do many of the things I've always wanted to do such as art, Ikebana flower arranging, golf, and being a house husband.

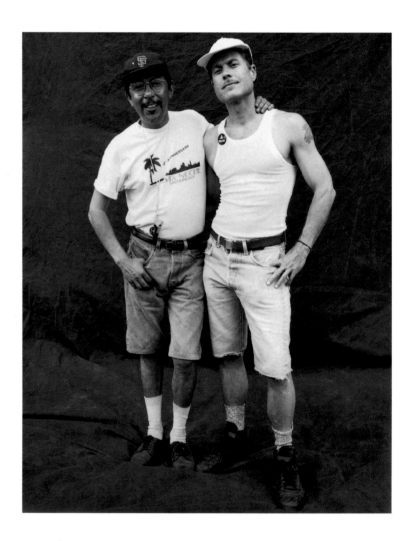

**COLE**

BORN: *May 18, 1953, New Brunswick, New Jersey*   RESIDENCE: *San Francisco, California*   EDUCATION: *B.A., University of California, Berkeley*
OCCUPATION: *Supervising/paralegal*   WHEN OUT: *1976*

**TOM**

BORN: *December 6, 1951, Los Angeles, California*   RESIDENCE: *San Francisco, California*   EDUCATION: *B.A., St. Mary's College of California*
OCCUPATION: *Hotel catering manager*   WHEN OUT: *1974*

# Barry D. Miller & David J. Weiner

## FOUR YEARS TOGETHER

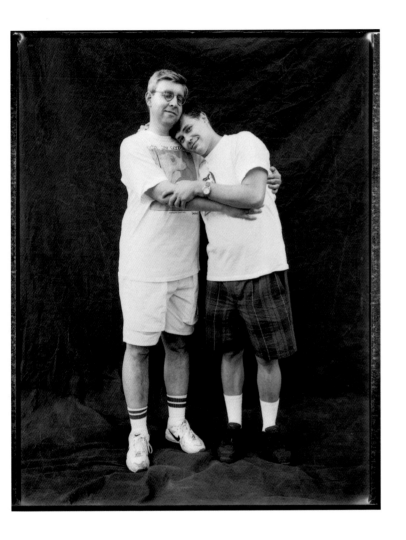

*How We Met* ❡ We met at the Gay and Lesbian Switchboard of New York, where we were both volunteers.

*Coming Out* ❡ BARRY: My parents, especially my father, was devastated. He wanted to commit suicide at first. ❡ DAVID: My family and I don't talk about it, but it has been overwhelmingly positive as far as friends and the job are concerned.

*Statement* ❡ BARRY: Not only do David and I live together, we also work at home together. You might say we're a twenty-four-hour-a-day couple. Before David, I can honestly say that there wasn't anyone I was involved with that I could be with for that much time. ❡ DAVID: Both of us were New Yorkers for many years. We decided to move to San Francisco at the beginning of 1993 and have loved it from the first day. Gay life here is so open and casual. We do try to visit New York during Gay Pride Week every June to see family and friends and to draw strength from the overwhelming energy and gay presence that the city is infused with. In San Francisco, every day seems like Gay Pride Day, so the influence of gay visitors isn't as noticeable.

*How We Spend Our Free Time* ❡ We enjoy traveling, eating out, seeing shows and movies, reading, listening to music, and just being together.

**BARRY**
BORN: *April 14, 1958, Philadelphia, Pennsylvania*   RESIDENCE: *San Francisco, California*   EDUCATION: *B.S., Marketing, New York University, 1980*
OCCUPATION: *Public relations consultant*   WHEN OUT: *1978, age twenty*

**DAVID**
BORN: *May 4, 1953, Brooklyn, New York*   RESIDENCE: *San Francisco, California*   EDUCATION: *Nassau Community College, Hofstra University*
OCCUPATION: *Writer/editor/jazz-record producer*   WHEN OUT: *1987*

# Ross Carson & Paul A. Vernon

## EIGHT MONTHS TOGETHER

***How We Met*** ❡ We met at a spaghetti warehouse restaurant in June 1992, before a gay-pride cruise. Neither of us realized at that time what would unfold between us. We've been together officially eight months, but if spiritual and emotional connectedness count for anything, then we've been together for many, many years.

***Coming Out*** ❡ ROSS: It meant suddenly and finally knowing that everything would be OK. The last hurdle is to come out at work, which feels like a huge goal at this point. ❡ PAUL: After coming out I could finally be myself. Although difficult, ultimately it was one of the most positive experiences. Except for my father and a brother, the whole family was pretty supportive. My mom was the best (of course!). Work has been tough. I try to keep my private life private when possible.

***Statement*** ❡ ROSS: Though we've only been together eight months, our mutual level of commitment is somewhere in the eighty-year range. We come from similar backgrounds and we were immediately able to recognize the real potential in each other when it suddenly and miraculously happened. Paul is the only man I've ever met, much less dated, with whom I could envision building a life. Commitment has ceased to sound like a four-letter word. ❡ We are a couple continuously working towards mutual respect, trying to step back when necessary or when taking the other for granted. We try to realign as we grow together, as complete and secure individuals, so we are prepared for more growth. ❡ We're just two normal, everyday guys like the rest of the world, except that we happen to be in love. We think our being gay is a real asset—not only are we lovers, we're best friends. We have an easy time relating to one another, an intragender empathy you might say, that makes just being together a fulfilling experience. ❡ We've been accused of being young (we're not that young) and starry-eyed. There's no way to describe what makes a relationship "right" without sounding clichéd. We both know that a good, healthy partnership takes a lot of work, which we're both discovering, and a lot of talking! But when it's right, it's right, and we find ourselves more and more in love every day.

***How We Spend Our Free Time*** ❡ PAUL: Working out, spending time with family, movies, travel, and art openings. We also volunteer for the AIDS Task Force of Cleveland. ❡ ROSS: We both have grown into spending free time as mutual caretakers of our relationship—talking, improving, enjoying, adjusting, compromising, laughing . . . with a lot of eating out and good sex thrown in.

### ROSS

**BORN:** *July 2, 1964, Urbana, Illinois*   **RESIDENCE:** *Cleveland, Ohio*   **EDUCATION:** *M.D., University of Iowa, Residency, University Hospitals of Cleveland*
**OCCUPATION:** *Anesthesiologist*   **WHEN OUT:** *To myself three summers ago, to everyone else in rather rapid succession*

### PAUL

**BORN:** *January 2, 1967, Akron, Ohio*   **RESIDENCE:** *Cleveland, Ohio*   **EDUCATION:** *B.S., Kent State University, B.A., Architecture, Kent State University*
**OCCUPATION:** *Architect*   **WHEN OUT:** *Winter 1985*

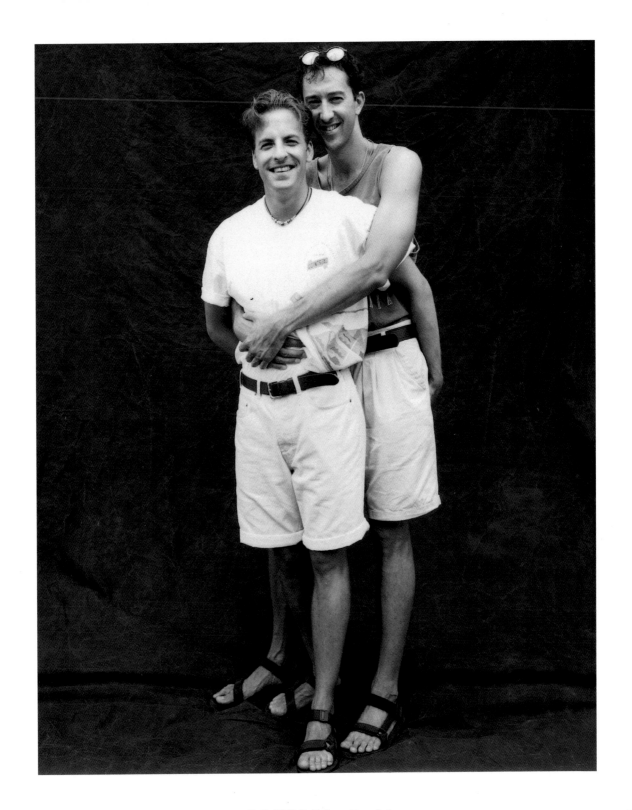

# Kelly Keller & Glenn Machuca

## ONE YEAR TOGETHER

*How We Met* ❡ GLENN: It was a hot sunny day when I first met Kelly along the Mississippi River at a gay beach. He introduced himself and we spent the day together. It was two months later when we met for the second time at a safe-sex party. A year later we are getting our first place together. ❡ We have done a lot of wonderful things together and there are many more to come. There is respect, trust, honesty, and unconditional love between us. Kelly is the most wonderful man I have ever met. ❡ KELLY: In the spring and summer of 1993 I talked to God and the universe often, asking for a lover I could really love, who would truly love me, whom I could really grow with. That lover came into my life on the hottest day of August, on the banks of the Mississippi River. It's been said that "love comes initially through the eyes," and though I'd felt that to be trite, it surely rang true when I saw Glenn, a vision in cut-off white jeans and a striped shirt. ❡ It was nearly three months before we met again. I'd been too nervous when meeting him to remember his name correctly and had no pen to get his phone number, but knew the restaurant he worked at in St. Paul. One late autumn day I finally got to St. Paul only to find the restaurant closed. That night I met Glenn again at a wild Halloween party. In this city where gay men often play anti-social games, I was taken aback that Glenn was as excited to see me as I was to see him again. I've been embracing and loving Glenn ever since. ❡ The initial qualities of Glenn which as-

tounded me were his sincerity, his huge heart, his honesty and his courage in stating his beautiful feelings. I knew early on that I trusted him enough to reciprocate how wonderful I felt with him. Glenn's presence is a wonderful garden in which to grow. I feel such peace and love when we're together. His Latin nature is soft, and he helps me to relax, laugh, and to find serenity in the most stressful times. ❡ We do fight but that's rare and when it happens we talk it out as immediately as possible, trying to understand one another. He gave me a poem at Christmas about the voyages he wishes to travel with me as my friend. Glenn is a most tender friend, a passionate lover and a devoted and most beloved mate.

*Coming Out* ❡ KELLY: Coming out to my parents really helped to see their unconditional love for me. I'd had preconceived limitations and misjudged how they could grow and love. That was a great healing and suddenly I gave myself permission to love my parents fully. It still feels like there's a lot of "process" to go through, but we're off to a good start. ❡ I still need to come out to a lot of people from my past, and I really need to work on my own internal homophobia. Life has been full of wonderful opening-ups in many realms since then and I really feel it has much to do with finally living in total honesty and self-love. ❡ GLENN: I first came out when I was twelve or thirteen. I had a nice support system of friends that helped me through the

process. At the same time I came out to my parents, then later on to my sisters and other friends. ❡ For me, coming out was the beginning of self-acceptance It opened up new opportunities with new friendships and with ones that had already been there. I also developed a very strong relationship with my sisters. My parents, on the other hand, were not as understanding. But it was totally worth it.

*How We Spend Our Free Time* ❡ KELLY: Relaxing with friends, working on photographs, reading, rollerblading, and taking day trips to explore new places. ❡ GLENN: I spend my time going clubbing, working out, or rollerblading. I like going out to different restaurants with Kelly and friends. I also love to spend time with my sisters and to walk my dog, Nakita.

---

### KELLY
BORN: *January 5, 1961, Dearborn, Michigan*　RESIDENCE: *Minneapolis, Minnesota*　EDUCATION: *B.A., Princeton, M.F.A., University of Michigan*　OCCUPATION: *Artist/photographer/teacher*　WHEN OUT: *1990 in Minneapolis, two weeks before Stonewall 1994 to my parents*

### GLENN
BORN: *September 23, 1968, Quito, Ecuador*　RESIDENCE: *Minneapolis, Minnesota*　EDUCATION: *Life*　OCCUPATION: *Make-up artist/waiter*　WHEN OUT: *Age twelve*

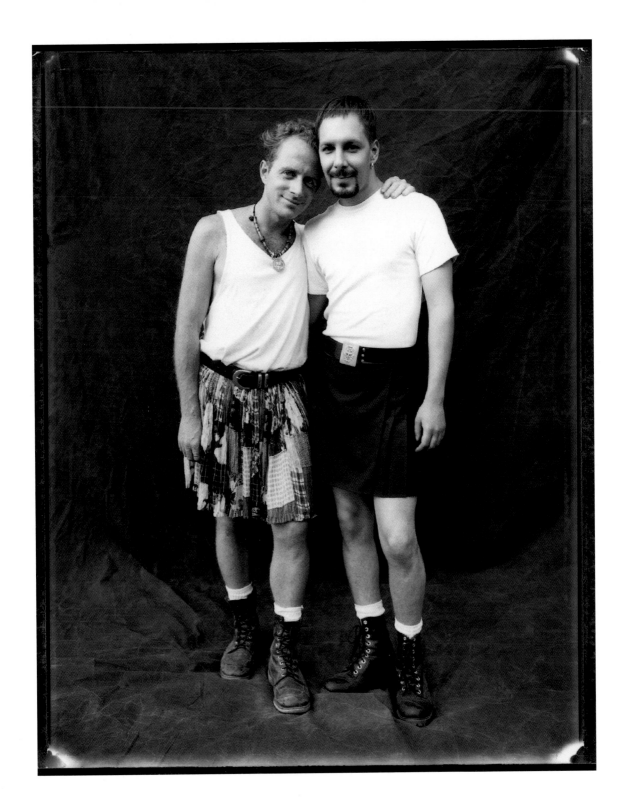

# Marvin Faleck & Anthony Ippolito

## TWO AND A HALF YEARS TOGETHER

*How We Met* ❡ Through a phone line.

*Coming Out* ❡ MARVIN: I guess I chose the right family and friends. Everyone was positive and my mother was perfect. ❡ ANTHONY: Friends and cousins were great but my mother was not as accepting. Marvin's mother was better about it when he told her a year ago. She was great. She knew I loved him and that we were happy together, so she was happy. She loved to go out with us, whether it was to take her to the doctor, or a movie, or out to eat. She loved to go to City Island, but she felt uncomfortable because she was in a wheelchair following a stroke. I only knew her for a couple of years, and she only knew about us for eight months before we lost her in March. Marvin talked about her and how she was so giving to him. She was always on the go, working at her job and showing Marvin the city. I felt sad when he told me about her and how she couldn't dance and run because of what the stroke had done to her body. But she didn't let it get her down. She was happy. Every time that we came to visit I think she knew that I was right for Marvin. Her name was Florence and she was the flower of life.

*Statement* ❡ MARVIN: We have generally been private people, but the beautiful spirit of the city the week of the Gay Games and the Stonewall 25 parade inspired us to pose for this picture because we felt comfortable. If the spirit of letting people be themselves could live on, the city and the world would be much better. Though sexual preference may have brought us together, our relationship is based on love and support.

*How We Spend Our Free Time* ❡ ANTHONY: Gardening on our terrace, travel, movies, quiet time on the couch, cuddling up and reading books, playing with the puppy, and kissing.

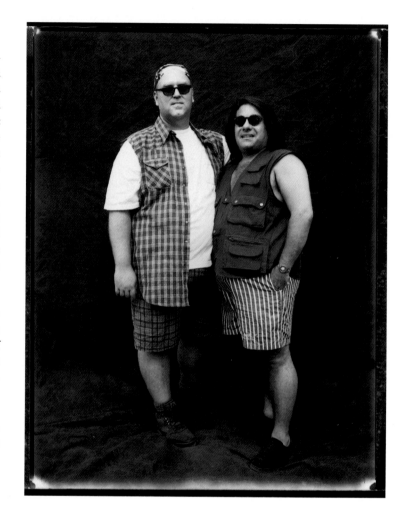

## MARVIN
**BORN:** *August 16, 1957, Philadelphia, Pennsylvania*   **RESIDENCE:** *New York, New York*   **EDUCATION:** *College graduate, Queens College (go figure)*
**OCCUPATION:** *Hair colorist*   **WHEN OUT:** *Three years ago*

## ANTHONY
**BORN:** *May 26, 1960, West Islip, New York*   **RESIDENCE:** *New York, New York*   **EDUCATION:** *High school*   **OCCUPATION:** *Manager*
**WHEN OUT:** *Two and a half years ago*

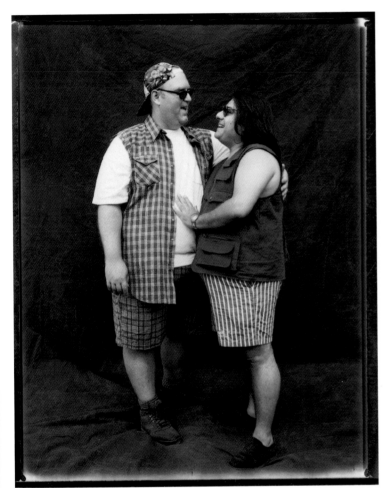 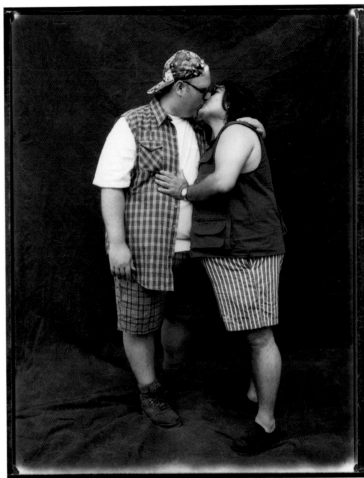

# Hiromi Ueki & Sandy Weames

## FOUR YEARS TOGETHER

***How We Met*** ¶ SANDY: I met Hiromi in Osaka, Japan in 1990. I was teaching English at the time and Hiromi walked into my classroom. I was immediately attracted to her. Unfortunately, it was my last week at the school. I gave her my telephone number on the last day of class and asked her to call me. It took a few months before we finally got together, but when we did, I knew we were meant for each other. ¶ We got married at a Shinto Shrine in Kyoto (not legally of course—the priest thought that he was uniting a strong friendship). We have been together for four years and have been married for three.

***Coming Out*** ¶ HIROMI: I came out after meeting Sandy in 1990. I was afraid of her at first. However, I was really afraid of admitting my sexuality. It is very difficult in Japan because it is not accepted and there is very little information about lesbian and gays. I felt so happy and free that I immediately told my best friend. She had seen the change in me, and could share in my joy. ¶ I was able to meet other Japanese lesbians, as Sandy had organized private lesbian and gay parties. I was surprised to find out that most of them had not told anybody about themselves. ¶ It seems like karma, but I feel that Sandy and I are just naturally meant to be together. I had no fears or reservations about leaving Japan, my friends and family, to come to Canada and be with Sandy. I also came out to my mother just before leaving. Sandy and I both spoke with her, and she took it

quite well. We are both looking forward to her visit next year. ¶ Of course we have problems communicating at times but we have to keep on trying. Most important is that we take responsibility and don't blame each other ¶ My life has turned 180 degrees and I love it. I'm working in a company that has same-sex benefits. I've walked in protest marches for gay and lesbian rights. I'm not ashamed of who I am and I feel great. I only wish that Japan and the rest of the world would open up more and accept lesbians and gays. ¶ If you truly want to be happy, then don't be afraid to take risks. Both Sandy and I took a major step in our lives and we couldn't be happier.

***Statement*** ¶ SANDY: Hiromi and I love life so we're quite active. We love the theater, music, karaoke, and having Japanese dinner parties. We love to travel and of course we enjoy taking in a Blue Jays game now and then. Most of all, we enjoy going to our place up north. It's a beautiful three-hour drive from the city where we enjoy peace and relaxation either alone or with friends. ¶ My advice for singles looking for a relationship is: love has no color, no language and no country. Your longtime companion is out there somewhere, as long as you don't narrow your options, e.g., only liking blondes with blue eyes. To couples, well, there's nothing more euphoric than an intimate loving relationship. However, staying as a couple takes a lot of work and commitment.

I feel the key to maintaining your relationship is open and honest communication. ¶ I'd like to wish all couples a long, lasting, and fulfilling relationship.

### HIROMI
**BORN:** *September 6, 1958, Totorri Prefecture, Japan*　**RESIDENCE:** *Toronto, Ontario, Canada*　**EDUCATION:** *Textile Design Diploma*
**OCCUPATION:** *Customer-service representative*

### SANDY
**BORN:** *July 1, 1958, Brantford, Ontario, Canada*　**RESIDENCE:** *Toronto, Ontario, Canada*　**EDUCATION:** *Child Care Worker Diploma and Travel and Tourism Diploma*
**OCCUPATION:** *Travel agent*

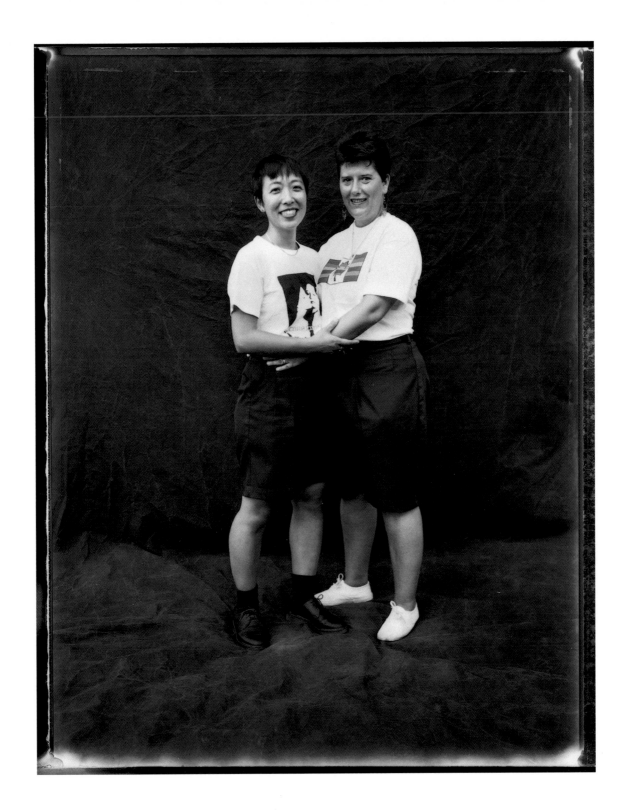

# Jose L. Acosta & Warren Brandriff, Jr.

## ONE YEAR TOGETHER

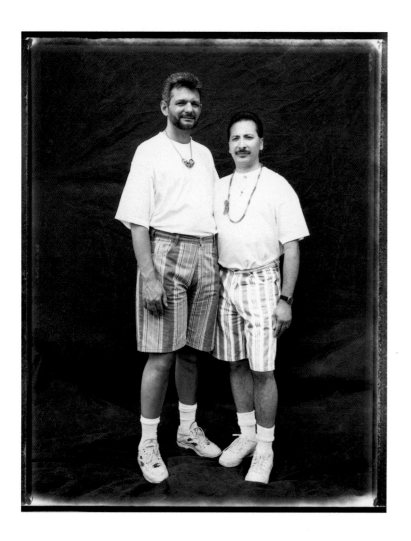

*How We Met* ¶ We met at The Monster, a night-club in New York City, during the Gay Pride weekend in 1993.

*Coming Out* ¶ JOSE: With my family it is not spoken about, but they know. With friends, all are supportive. ¶ WARREN: I had less problem with family, friends, and work than driving in traffic during rush hour. As far as religion goes, that's something you carry within anyway. I have a strong faith with God and I know that He has a lot to do with my happiness.

*Statement* ¶ JOSE: I met Warren in the summer of 1993 after the breakup of a twelve-year relationship. Now I am very happy. Warren is everything to me and I love him very much. ¶ WARREN: When I met Jose, he was the most down-to-earth person I had ever met. He in no way tried to impress me; he was simple and honest. How could anyone not love someone like that? This past year has been great. He's never boring. He has a great sense of humor (sometimes a little sick). He can always make me laugh.

*How We Spend Our Free Time* ¶ We enjoy movies, overnight trips, dinner guests, antique shopping, and spending time with family.

### JOSE
**BORN:** *March, 14, 1960, Bronx, New York*　**RESIDENCE:** *Mays Landing, New Jersey*　**EDUCATION:** *High school / technical school*
**OCCUPATION:** *Casino slot attendant*　**WHEN OUT:** *Summer 1985*

### WARREN
**BORN:** *June 28, 1955, Bridgeton, New Jersey*　**RESIDENCE:** *Mays Landing, New Jersey*　**EDUCATION:** *High school*
**OCCUPATION:** *Casino slot supervisor / host*　**WHEN OUT:** *Age eighteen*

# Janet Goldstein & Teresa Palomar

## SIX YEARS TOGETHER

**How We Met** ❡ TERESA: Although we knew each other through our local feminist bookstore, our relationship really began when Janet plotted to pick me up after a women's rap group. ❡ JANET: I picked her up after a women's rap group.

**Coming Out** ❡ JANET: Coming out changed everything for the better, except I'm still an atheist. ❡ TERESA: Not much changed at all. However, I am closeted at work, since I teach at a Catholic school.

**Statement** ❡ TERESA: If we were straight, we would be considered a rather boring, humdrum, happily married couple. We own a house together, we work, we pay taxes, we entertain guests, and do all those everyday things straight couples do—so much for the "gay lifestyle." As far as a "gay agenda" is concerned, ours seems to focus on doing the dishes, grocery shopping, and making the mortgage payments. It also includes fixing a leaky garage roof, having the chimney cleaned, and waterproofing the basement. And after all that, we're supposed to plot the overthrow of "traditional family values?" I don't think so. We're too busy living them.

**How We Spend Our Free Time** ❡ JANET: playing on my PC. ❡ TERESA: I, too, enjoy computers, but more for the games. I also play tennis.

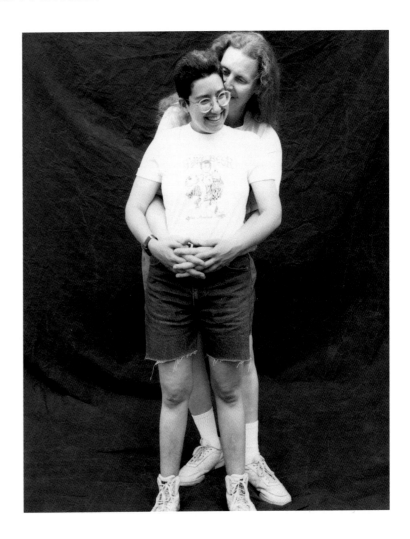

### JANET
**BORN:** *September 8, 1963, New York, New York* **RESIDENCE:** *Baltimore, Maryland* **EDUCATION:** *B.A., Johns Hopkins University*
**OCCUPATION:** *Computer technician/analyst* **WHEN OUT:** *Age twenty-three*

### TERESA
**BORN:** *January 3, 1954, New Kensington, Pennsylvania* **RESIDENCE:** *Baltimore, Maryland* **EDUCATION:** *B.S., Education, Indiana University of Pennsylvania, some graduate work* **OCCUPATION:** *Middle-school teacher* **WHEN OUT:** *April 1988*

# Kenneth E. Binder & Stephen A. Lenius

## ONE YEAR TOGETHER

***How We Met*** ❡ KEN: We met in a support group for survivors of gay domestic abuse. We are both survivors of abusive long-term gay relationships. I did not want another relationship, this just happened, and I'm so glad it did. Many years ago I read *My Son Eric*—the story of a mother coming to terms with a gay son—and often wondered what happened to Eric. Only after meeting, dating, and falling in love with Steve did I find that he was Eric. (Eric is his pseudonym in the book.) ❡ STEVE: And he didn't believe me when I told him I was Eric. I had to get the book off the shelf and show him the inscription my mother had written to me.

***Coming Out*** ❡ KEN: Breakup of marriage, loss of three children, loss of many friends and a sister. I also lost my job and ultimately left the church. I ended up in a treatment center and started eighteen-plus years of continuous sobriety, a new life, self-respect and happiness! ❡ STEVE: Coming out was the first decision I ever made by myself without really caring what other people thought. It gave me the freedom to reassess other areas of my life. ❡ I left college after realizing that I was there not because I wanted to be but because that was where I was expected to be. ❡ My father, a Protestant minister, my two sisters, and my brother-in-law took the news well and were supportive. My mother, however, was heavily involved in Pentecostal/Fundamentalist Christianity at the time, and she went off the deep end. She fasted on rice and held exorcisms in absentia to drive the demon out of me. Eventually it dawned on her that the problem was not me, but her reaction to me. She did a complete turnaround and has become a gay activist in her own right. Her name is Mary Borhek, and she is the author of two well-known books: *My Son Eric* and *Coming Out to Parents*.

***How We Spend Our Free Time*** ❡ KEN: We do not have a lot of free time. Steve holds the title of "Great Lakes Mr. Drummer 1994," so a lot of our time is spent with title-holder duties. We also volunteer for AA, AlAnon, AIDS fundraising, ACA twelve-step groups, and the North Star Gay Rodeo Association. In what little time is left we shop for antiques, work on house projects, dance (two-step), travel, eat out with friends, and spend time with our dog (Afghan) and cat (Siamese). We also spend time with family. I have a gay son, and we have quite a lot of contact with Steve's family. ❡ STEVE: I have designed logos for the Twin Cities Gay Pride Festival and I am working on another one. I do a lot of writing— poems, magazine articles, and music and lyrics for two theater pieces that are currently in the works.

### KENNETH

**BORN:** *August 30, 1943, Flint, Michigan*   **RESIDENCE:** *Minneapolis, Minnesota*   **EDUCATION:** *M.A., Northern State University*   **OCCUPATION:** *Interior designer*   **WHEN OUT:** *1975*

### STEPHEN

**BORN:** *August 4, 1955, Fargo, North Dakota*   **RESIDENCE:** *Golden Valley, Minnesota*   **EDUCATION:** *Hamline University*   **OCCUPATION:** *Consulting and production in typography, electronic publishing and the graphic arts*   **WHEN OUT:** *1974*

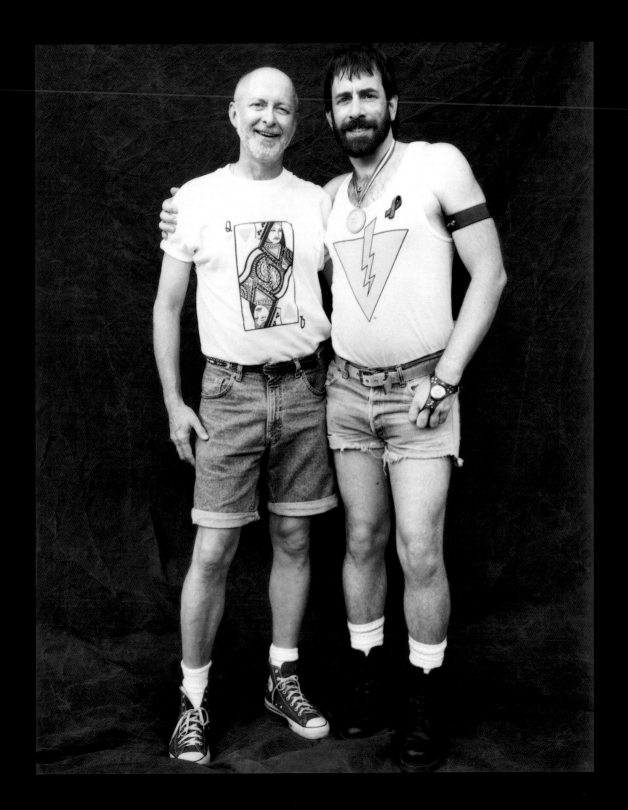

# Jerry L. Chavez & Clark Ebbert

## TWO YEARS TOGETHER

*How We Met* ¶ We met at a dance bar called Badlands in Washington, D.C. We were both dancing on a speaker box.

*Coming Out* ¶ JERRY: My family is very receptive. I could not, nor will I, come out to friends in South Dakota. I could not come out at work without fear of reprisals. ¶ CLARK: Coming out has made me much more integrated. I get to be the same person in every situation. People who can't deal are lost along the way. No regrets.

*Statement* ¶ JERRY: Clark and I get along so well because we agreed to establish a "No j&p" rule—no jealousy or possessiveness. We were both in previous relationships where we felt stifled. The last thing I want to do is alter his wonderful disposition and personality by becoming jealous or possessive of his friendly nature with other people. Another mark of our relationship is the sharing of household responsibilities. ¶ After having been together practically every day since we met, I feel as though the passionate flame of love between us burns even stronger with each new day. ¶ CLARK: Jerry and I are nearly complete opposites. We fit like pieces of a puzzle. Jerry is the grounding force, the homemaker, the very sensible one. I'm more social, intuitive, and spontaneous. Together we make a whole. ¶ The single most fascinating part of our relationship is our involvement in gay sports. Jerry helped me (an historically inept sissy) learn to enjoy my athletic side. He is so proud of my accomplishments. I've gotten to recapture the Little League experiences I missed as a kid. He's the best.

### JERRY
**BORN:** *February 10, 1954, Chamberlain, South Dakota*    **RESIDENCE:** *Arlington, Virginia*    **EDUCATION:** *B.S., M.B.A.*    **OCCUPATION:** *Retired*
**WHEN OUT:** *1984 partially, 1993 to family*

### CLARK
**BORN:** *February 26, Aliquippa, Pennsylvania*    **RESIDENCE:** *Arlington, Virginia*    **EDUCATION:** *B.A., Psychology, Duquesne University, M.A., Dance Performance,*
*Ohio State University*    **OCCUPATION:** *Office manager for medical practice*    **WHEN OUT:** *1983 to myself, out to family in 1987*

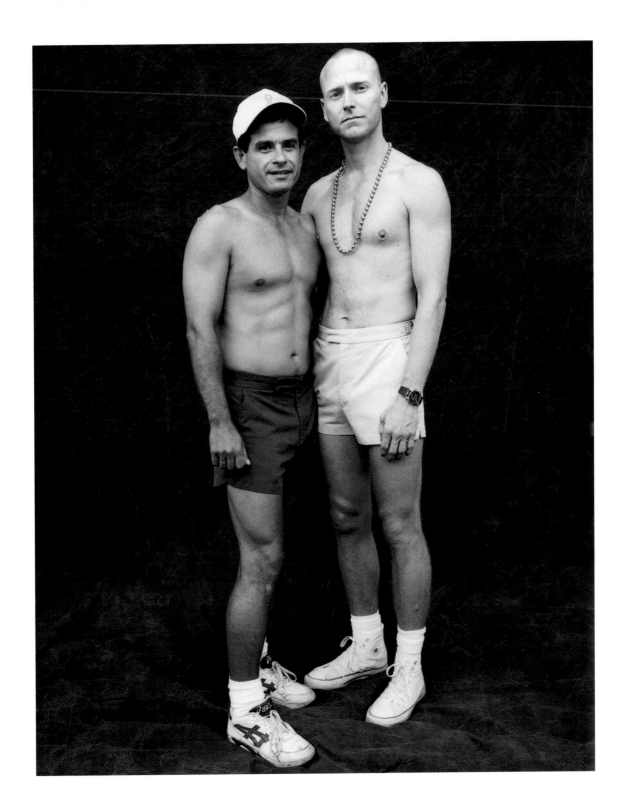

# Niki Cushing & Jill Otersen

## THREE AND A HALF YEARS TOGETHER

***How We Met*** ¶ NIKI: I met Jill at a gay bar. I was dancing and noticed her with a couple of ladies. I asked her to dance. We did and later that night I gave her my number. At the time I was getting out of a relationship. I returned to the club the next weekend not hearing from Jill. At the club, Jill came in. She and I talked that night, and found out we are both not aggressive, so we had to try to be more aggressive—otherwise we would never get together. Later that week we met for lunch and saw each other on and off for six months, until we decided we were great together. And here we are today. ¶ JILL: We met at a gay bar. I was there with friends and Niki came up and asked me to dance. We danced once and that was it for the night except for constant eye contact from across the bar. Unfortunately, I found out that she was already involved with someone. We became friends over the next few weeks and her other relationship was broken off. I have been in love with her ever since.

***Coming Out*** ¶ NIKI: The coming-out process was what I expected. Mom tried to find out what made me turn gay and did a lot of her own research to help cope with it. Finally, she understood that I was simply born that way. Like anything else time helps things become more clear. I have five brothers and sisters and they all feel that if I'm happy, it's OK with them. The one person who it really affected was my best friend. We had been friends for two years when I told her. She didn't say a word. We never spoke again. Her reaction made me more careful about who I chose to be my friend or who I tell. ¶ JILL: My parents had a very tough time with it. My sister accepted it. Friends tended to step away. The funny thing is, you tell total strangers the most personal things about yourself, and you're afraid to tell the people who are important to you. The good thing about coming out is that I can now let my family enjoy my life with me. It felt so good not to have to lie anymore. After being out for ten years my mother loves my girlfriend like a daughter and my father thinks of her as the son-in-law he will never have.

***Statement*** ¶ JILL: Niki is the most wonderful girlfriend I could ever imagine. She is the most loving and caring woman in my life. We spend a lot of our time laughing and just enjoying ourselves. I think that I am very lucky to be able to spend all this time with Niki, as we love and take care of our mutual needs. I have found my mate for life and we both work at making sure that our lives are happy.

***How We Spend Our Free Time*** ¶ We bowl in a league in the winter. We are also on a softball team. We spend time helping out our families. We live right on the ocean so in the summer we do a lot of laying out and taking in the beautiful view.

## NIKI

**BORN:** *July 18, 1962, Elizabeth, New Jersey*   **RESIDENCE:** *Sea Bright, New Jersey*   **EDUCATION:** *High school/graduate; Army*   **OCCUPATION:** *Landscaper*   **WHEN OUT:** *Age sixteen*

## JILL

**BORN:** *September 15, 1962, Jersey City, New Jersey*   **RESIDENCE:** *Sea Bright, New Jersey*   **EDUCATION:** *High School/graduate; Dental Assistant School (R.D.A.)*   **OCCUPATION:** *Registered dental assistant (I am about to open a country craft store with Niki)*   **WHEN OUT:** *Age twenty-two, at work about five years later*

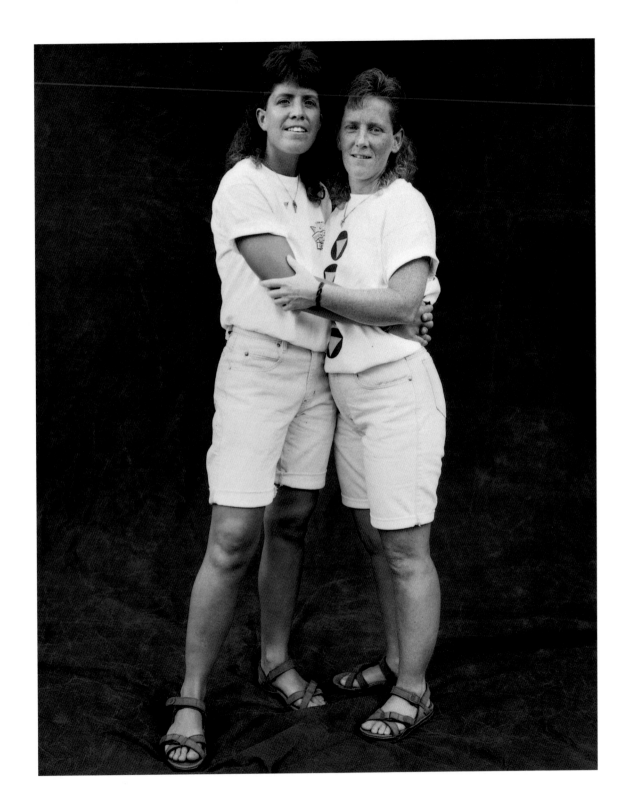

# Derwin Dashiell & Marty Leach

## ONE YEAR TOGETHER

*How We Met* ¶ We met at We the People Life Center.

*Coming Out* ¶ DERWIN: Made my eyes open wider. ¶ MARTY: Still working it out.

*How We Spend Our Free Time* ¶ We enjoy cooking, entertaining, basketball, friends, and listening to music.

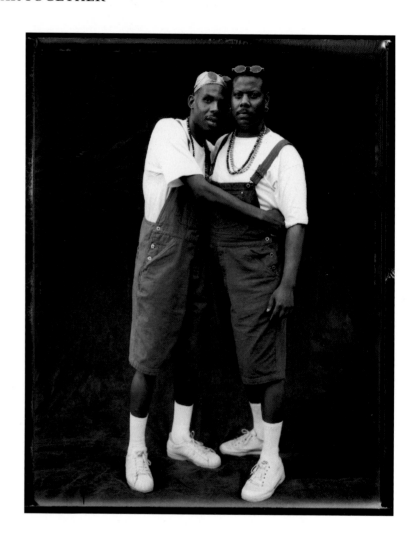

### DERWIN

BORN: *December 11, 1956, Newport News, Virginia*  RESIDENCE: *Philadelphia, Pennsylvania*  EDUCATION: *Bowie State University*
OCCUPATION: *Counselor (for those living with HIV and AIDS) at We the People Life Center*  WHEN OUT: *1973*

### MARTY

BORN: *January 19, 1965, Philadelphia, Pennsylvania*  RESIDENCE: *Philadelphia, Pennsylvania*  EDUCATION: *High school*
OCCUPATION: *Clerk at a paint store*  WHEN OUT: *1988*

# Glenn Hammet & Keith Millay

## SEVEN YEARS TOGETHER

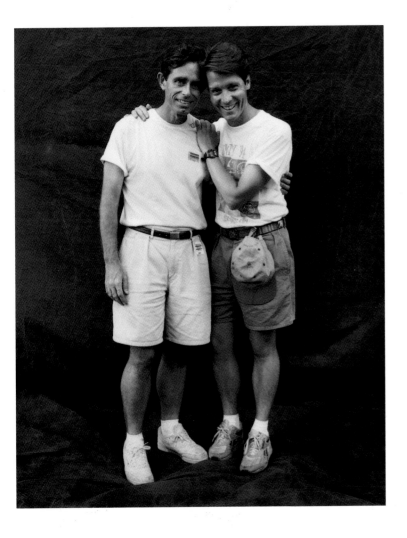

*How We Met* ¶ KEITH: We met in Boston. Glenn became a tenant in a townhouse I owned with a straight couple. I lived in the building.

*Coming Out* ¶ KEITH: Coming out affected my life in a very positive way, opening my life to family and friends for the first time and opening the way to expand my circle of friends and experiences. ¶ GLENN: Only positively.

*Statement* ¶ KEITH: We complement each other with our unique views of people, society, and ourselves. We respect each other's views and "nature." ¶ We share a common respect for people and their dignity. This is reflected in our professional choices. We enjoy our home, friends, travel, eating out, and dining in.

*How We Spend Our Free Time* ¶ We enjoy gardening, reading, travel, and long-distance running (we are members of Frontrunners, Boston). We firmly believe that a family that runs together, stays together.

### GLENN

**BORN:** *February 21, 1957, Lexington, Kentucky*  **RESIDENCE:** *Boston, Massachusetts*  **EDUCATION:** *College*  **OCCUPATION:** *Program coordinator, Community/Service Learning Project*  **WHEN OUT:** *1983*

### KEITH

**BORN:** *December 28, 1950, Indianapolis, Indiana*  **RESIDENCE:** *Boston, Massachusetts*  **EDUCATION:** *College*  **OCCUPATION:** *Architect*  **WHEN OUT:** *1984*

# Julie E. Chuplis & Barbara Wray Smyth

## THREE YEARS TOGETHER

**How We Met** ¶ JULIE: We met on the bus to the march on Washington, D.C., on April 25, 1993. We spent the day with a group of people but sat together on the ride home. As we talked, we discovered more and more things we had in common. We grew up within a mile of each other. We attended the same schools. Our family backgrounds and values were very similar. We both enjoyed the Philadelphia Folk Festival. We even had lived within a mile of each other for the past ten years. It all seemed too good to be true. We didn't begin to date until the end of June. ¶ BARBARA: One look into Julie's green eyes and I knew she was the one for me. It seems as if our lives ran parallel to one another until we were both ready to find love, and that's when we met. We are looking forward to our commitment ceremony as soon as my divorce is final.

**Coming Out** ¶ JULIE: I came out to myself six years ago. I was married at eighteen and divorced at twenty-three. I raised three children as a single parent but something was always missing in my life. I came out to my family in 1993. My family did not understand at first, but they seem to be more accepting now that they see how much happier I am. My daughters are now adults and my problems with them are more about sharing me with another person than with my being a lesbian. My son was upset only that I didn't tell him sooner. ¶ BARBARA: I came out in 1974. My mother prayed me straight, and I went back into the closet in 1978. I was married in 1979 and had two children. I came out to stay in 1992 and separated from my husband in 1993 when I could no longer live a lie. My two children, ages six and fourteen, live with their father because he has the financial resources to care for them. I was a stay-at-home mother and only working part time. My husband refused to leave so I left without my children. I am seeking a divorce from my husband and we are involved in a custody dispute. I feel I am finally living the life I was meant to live. I am no longer plagued by depression and self-doubt. My ex-husband is still in shock after all this time. My children are doing well, and I see them often since we live within a mile of each other. My mother and sisters cannot understand what I did. I am estranged from two of them and their families. I feel my mother is more accepting of our relationship than she was at first.

**How We Spend Our Free Time** ¶ BARBARA: We share many interests but we have enough differences to keep things from being boring. Julie introduced me to square dancing, and to my surprise it was fun. We enjoy the IAGSC (International Association of Gay Square Dancing Clubs) conventions and fly-ins. We also like to camp and enjoy our time alone in a cabin in the Adirondacks several times a year. Mostly we spend our time doing everyday types of things. Our relationship is built on communication. We say what we mean and we mean what we say. We feel a mutual respect and each of us wants the other to be able to reach her true potential. After living our lives apart we both know how truly lucky we are to have found one another.

## JULIE

**BORN:** *November 5, 1948, Darby, Pennsylvania* **RESIDENCE:** *Upper Darby, Pennsylvania* **EDUCATION:** *M.A., Education, Temple University* **OCCUPATION:** *Reading specialist in an elementary school* **WHEN OUT:** *Six years ago*

## BARBARA

**BORN:** *January 8, 1953, Drexel Hill, Pennsylvania* **RESIDENCE:** *Upper Darby, Pennsylvania* **EDUCATION:** *B.A., German; currently working on M.I.S., Drexel University* **OCCUPATION:** *Graduate student* **WHEN OUT:** *1974*

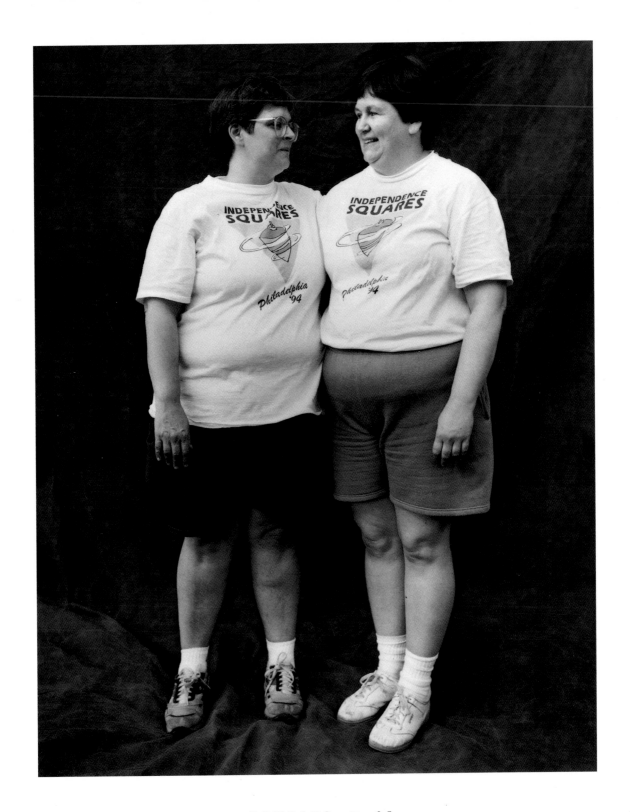

# Michael Brands & Robert Ollinger

## TEN YEARS TOGETHER

***How We Met*** ❡ MICHAEL: We first met almost ten years ago when we were putting together a photo event at a new club (Cignel). I had recently moved from New Orleans to Baltimore to go to graduate school. My favorite memory is of one of our first dates. We went to Patapsco Valley State Park and hiked down to the valley floor. We then waded across the river and climbed up the rocky course of a stream with small waterfalls along our route. At the top we rested, played in the stream, and etched our initials on a tiny rock. ❡ We've gone on many trips and discovered many weird and wonderful places, both natural and man-made, since then. I think of that rock now and then, tumbling gradually toward the valley floor, as a talisman binding us in a relationship that was blessed by nature and held together by our love of things beautiful and adventurous. ❡ ROBERT: We first met at a dance club in Baltimore. A mutual friend asked us both to show photographs in the club's gallery. Michael called me to see how I was mounting my shots. To make a long story short, I ended up spinning the records at the club and Michael had his very own one-man show. After that, once we were formally acquainted, we began dating.

***Coming Out*** ❡ MICHAEL: When I was nineteen my parents asked if I was gay because they had recently met one of my more "expressive" friends. ❡ ROBERT: At nineteen my mother read a steamy letter from my boyfriend, so my "coming out" sort of emerged. ❡ MICHAEL: My parents were awkward about it for about a year, but they had gay friends so they came to terms with it. I had already begun to separate from less compassionate straight friends to build friendships with gays or homophiles. ❡ ROBERT: My mother initially went through hysterical shock but now she comes over and brings baked goods and sends Michael cute cards.

***Statement*** ❡ ROBERT: We supported each other while we finished graduate school. Money was tight but we had intense, wonderful days driving through the countryside taking photos at roadside attractions. We're especially fond of offbeat oddities (e.g., the birthplace of Mother's Day at Hallam Shoe Hotel). Our biggest compromise has been musical; I promised not to play Diamanda Galas's *Litanies of Satan* if Michael put away his Stevie Wonder album, *Songs in the Key of Life*. ❡ My parents appreciate Michael. My mother bakes for him and tells him about our heritage. My father talks endlessly about how to remodel our fixer-upper home. (He finally got the son he always wanted.) Michael's parents always have a bed for us in New Orleans when we visit. His mother even went with us on a road trip to Maine, where we stayed at our favorite gay bed and breakfast. Sometimes our friends believe we are sexually dead because we have been together so long. That's when we reveal something shocking to show that commitment doesn't have to be tedious. ❡

Our dream is to move to Vermont and open our own bed and breakfast. Michael wants a baby and I want some chickens. That should make an interesting compromise.

***How We Spend Our Free Time*** ❡ MICHAEL: Freelance graphic design jobs, working on the house, writing friends, canoeing, and road trips. ❡ ROBERT: Watching films, writing my screenplay, canoeing, and road trips.

---

**MICHAEL**
**BORN:** *October 15, 1955, New Orleans, Louisiana*   **RESIDENCE:** *Baltimore, Maryland*   **EDUCATION:** *B.F.A., Graphic Design, M.A., Publications Design*
**OCCUPATION:** *Graphic designer*   **WHEN OUT:** *Age nineteen*

**ROBERT**
**BORN:** *October 6, 1957, Baltimore, Maryland*   **RESIDENCE:** *Baltimore, Maryland*   **EDUCATION:** *B.S., Journalism, M.A., Publications Design*
**OCCUPATION:** *Graphic designer*   **WHEN OUT:** *Age nineteen*

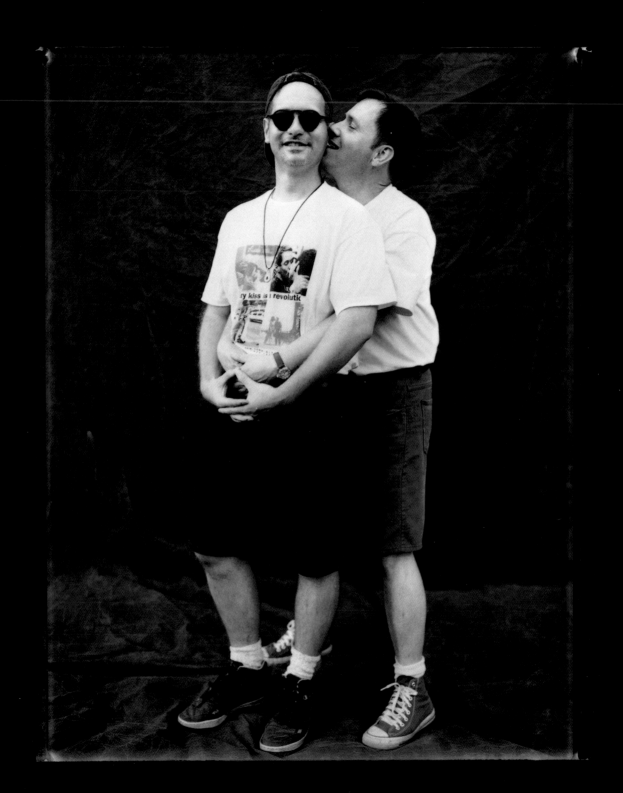

# Javier Lara & Mark Corkery

## TEN MONTHS TOGETHER

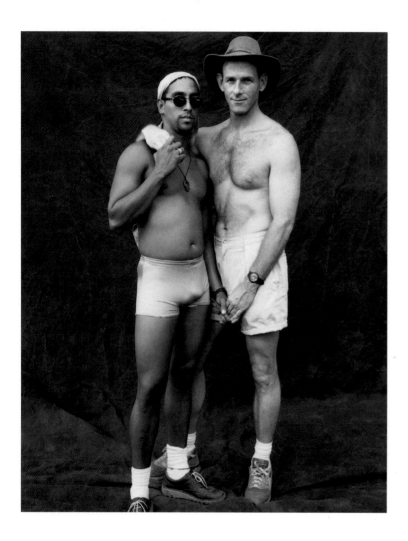

*How We Met* ❧ At a bar in South Beach, Florida.

*Coming Out* ❧ MARK: There was not really any effect on me. Parents and staff have been supportive. ❧ JAVIER: Ditto.

*Statement* ❧ Our relationship is very positive. We have mutual and individual friends. Our trust in ourselves and each other enables us to have a very open and caring relationship. Although it sometimes is tiring, our love is evolving to a very healthy, mature place. Our age difference is proving to be an asset and not an issue.

*How We Spend Our Free Time* ❧ Doing art galleries, museums, the beach, and working out.

### JAVIER
**BORN:** *May 12, 1965, Caracas, Venezuela*   **RESIDENCE:** *Long Beach, California*   **EDUCATION:** *B.F.A., Rhode Island College*   **OCCUPATION:** *Health educator and artist*
**WHEN OUT:** *Two years ago*

### MARK
**BORN:** *May 23, 1954, Troy, New York*   **RESIDENCE:** *Long Beach, California*   **EDUCATION:** *M.Ed., Harvard University*   **OCCUPATION:** *College counselor*
**WHEN OUT:** *Five years ago*

# Arthur "Chip" McHugh & Walter Trider

## ONE MONTH TOGETHER

*How We Met* ¶ WALTER: Gay Pride Boston, June 11, 1994. We fell deeply into each other and spent one solid month together from Gay Pride Boston to Stonewall (Independence Day, for our straight friends). After one month of bliss the fact that we were a struggling artist and a struggling photographer proved to be far too great a burden. We've tried again but split for good. Another time, another place, along the rainbow.

*Coming Out* ¶ WALTER: Coming out was hard on my friendships; I lost half my friends, but retained the other half. My brother had been out for about ten years when I came out to the family. My grandmother thought I was the last hope to marry a nice Irish Catholic girl (I was the youngest boy out of seven), but my belief that religion has killed more than it will ever save cast a long shadow over my family's faith. They love me, but my homosexuality is just known, not a topic of discussion. But with six preceding siblings, my parents had been shocked before yet adapted to the changes of the '60s, '70s, and on through the '80s.

*How We Spend Our Free Time* ¶ WALTER: Paint, develop my window-painting business, cook, read, meditate and socialize. I also curate at a restaurant and talk on the phone incessantly.

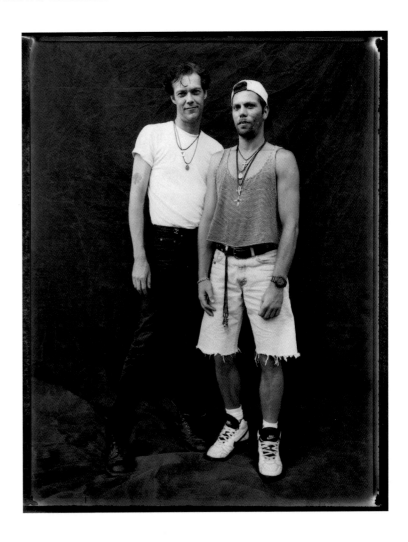

**CHIP**

BORN: *January 11, 1968, Woburn, Massachusetts*   RESIDENCE: *Quincy, Massachusetts*   EDUCATION: *High school*   OCCUPATION: *Photographer*
WHEN OUT: *Age twenty-three*

**WALTER**

BORN: *April 4, 1961, Boston, Massachusetts*   RESIDENCE: *Boston*   EDUCATION: *Six-plus years bouncing around Boston's art schools*
OCCUPATION: *Sales for gay newspaper/gay telemarketing firm, artist, entrepreneur, curator*   WHEN OUT: *1988*

# Amy Buchanan & Lisa Neuburg

## SIX MONTHS TOGETHER

**How We Met** ❡ We had a biology class together at UW-Milwaukee in the fall of '93.

**Coming Out** ❡ AMY: The hardest part about coming out was not telling my family or friends, it was actually admitting to myself that I was gay. Coming out to myself took years. All through high school I felt like something was wrong with me. I felt different than all my friends and spent most of my time pretending to like guys. I had one boyfriend in high school who I cared about very much, but I wasn't sexually attracted to him. This is when I started to suspect I might be gay. I started hating myself and I tried to deny the fact that I had feelings for some of my women friends. It made me sick. I wasn't supposed to feel that way; it just wasn't normal. I tried so hard to ignore and repress my love for women, but it was impossible. I got to the point where all I could think about was, "Oh God, what if I am gay!" I would have rather died. ❡ The reason I felt that way was because I grew up in such a conservative midwestern town. I didn't know any gay people. I only knew what I saw in a few low-budget films and from jokes people cracked. I thought if I was gay, I would have to chop off all my hair, act real tough, and hate men. That wasn't me. I was a pretty, long-haired girl who played lots of sports in high school and did not hate men. ❡ During my sophomore year in college I almost had a breakdown. I needed to know who I was. I went to talk to a thera-pist. It was the best thing I ever did for myself. She made me realize I was not a bad person for having the feelings I had. I couldn't help the way I felt and I had to deal with that and move forward in my life. I still was not convinced that I was gay. I would not declare myself a lesbian until I was actually with a woman. ❡ It finally happened that summer. I fell in love with a woman I worked with. We got to be close and shared our deepest thoughts with each other. It turned out that she had been going through a lot of the same things I had. She was unsure of her sexual identity; she had always wanted to be with a woman but was too afraid. I think everything worked out so well because we were such good friends. We ended up being together for about six months. In that time we helped each other really learn about ourselves. It was one of the most exciting times in my life. I felt like I had just been born. ❡ I know not all gays go through such a difficult coming-out period but it was so hard for me and I would just like to tell people going through rough times that it does get better. If I learned one thing through all this it is that being gay is not a choice. I can't change the fact that I love women. I love who I am. If you don't have that you don't have anything ❡ LISA: Coming out to myself, finally realizing that I was gay, was the easiest part of the entire process. Up to that point, my life had always seemed to be a bunch of puzzle pieces that never quite fit together. Now I have the whole picture and everything fits. ❡ Unfortunately, the other components of my life were much scarier to deal with in regard to my gayness. I was raised in a strict Catholic family in rural Wisconsin, which was not extremely conducive to the gay life-style. The community in which I was raised was small, cold, and very unforgiving. I wanted to move away, even as a small child, so I did. I love living in the city and the city is certainly more accepting of alternative life-styles. My family figured out that I was gay probably as early as I did, but we didn't talk about it for nearly four years. I never really tried to hide it from them, but I also didn't want to shove it in their faces. I know how my family functions and I knew that when they were ready to really deal with it, they would bring it up. In the meantime, my family befriended my friends (and girlfriends) and welcomed them into their home for holidays and birthdays. Nothing really changed when my mom finally asked if I was gay and I answered yes. It was actually a relief for me. ❡ As for my friends, I pretty much left my childhood friends when I left my hometown. A few people that I did stay in touch with pretty much just eliminated me from their lives after they found out. Just as well, I guess. ❡ As far as work goes, I have a few gay friends and a few gay-friendly friends and the rest are just coworkers. I have always thought that work and private lives are much safer as separate entities, no matter what one's sexual orientation. ❡ Probably, the most difficult aspect of my life is being in the military (reserves).

### AMY

**BORN:** *May 17, 1972, Neenah, Wisconsin*   **RESIDENCE:** *Milwaukee, Wisconsin*   **EDUCATION:** *University of Wisconsin-Milwaukee*
**OCCUPATION:** *Student*   **WHEN OUT:** *Summer 1992*

### LISA

**BORN:** *August 7, 1969, Hustisford, Wisconsin*   **RESIDENCE:** *Milwaukee, Wisconsin*   **EDUCATION:** *University of Wisconsin at Milwaukee*
**OCCUPATION:** *Student / hospital unit secretary*   **WHEN OUT:** *Summer 1988*

This forces me to be much less open about my life and does create some internal unrest for me. Some of my friends think that I should get out because it makes a hypocrite out of me, but I disagree. I enjoy certain aspects of the military, and the income and school assistance are invaluable to me. I figure that it's kind of humorous because the military claims homosexuality is incompatible with military service. So let them pay me for my time and help me pay for school and when the time comes, watch me walk into my commander's office and tell him I'm gay! There's nothing they can do when my time's up— they cannot recollect the money—so it's just their loss and my gain. Yes sir!

*How We Spend Our Free Time* ❡ AMY: Movies, rock climbing, biking, camping, working out, snuggling, and laughing. ❡ LISA: Watching movies, working out, rock climbing, talking/contemplating life and the future, just hanging out, and laughing.

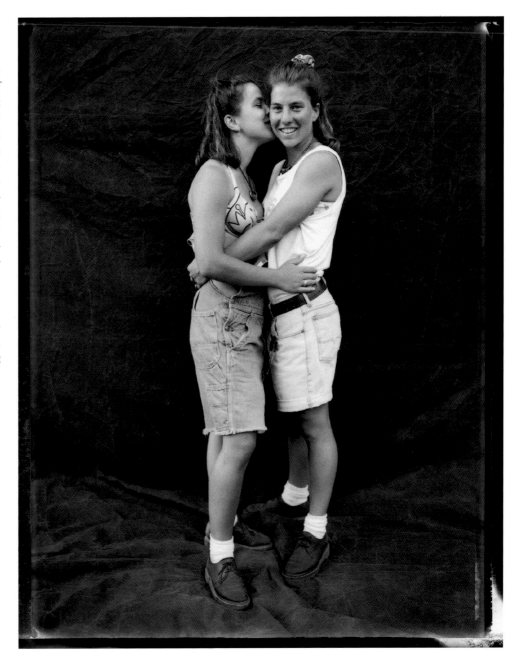

# Christopher "Topher" Grinnel Corbett & Joe Tate

## EIGHT YEARS TOGETHER

*How We Met* ¶ TOPHER: We met through a mutual friend at a nightclub in Richmond, Virginia. We went on a date shortly afterwards. It was not love at first sight, but one date turned into an eight-year relationship.

*Coming Out* ¶ TOPHER: On a Saturday night during my senior year in high school, I said "I'm gay!" out loud for the first time. It was late and my best friends (all female) just listened. One of the girls offered to sleep with me to "save me," and another thought I'd said it to be cool. The best reaction was from Liza, my sister, who just accepted me as she always had. ¶ Coming out to my family has only been positive, partly due to the fact that my father (who is also gay) and my mother are advocates for civil and human rights. Along with my stepfather, who is a minister and sex therapist, they have always nurtured me to be the person that I am. ¶ JOE: My first memory of coming out is hearing my mother on the phone saying, "I know a lot more than you think I do!" She had found a letter I had written to God asking him to help me with my "problem" and saying how I was trying not to have evil or sinful thoughts. I was about twenty when I wrote this note, and she found it several years later while snooping in my old room. ¶ I grew up in a small Bible-belted southwest Virginia town and being gay was not talked about, much less something to be proud of. Until my early twenties I thought something was wrong with me or that I was being punished for something. I've always known that I was gay and finally I had to decide to be happy and accept it, or be miserable and live a lie. ¶ My family was split on the subject. My mom and one sister had a harder time dealing with it than my dad and another sister. Half of the battle was to get them to talk openly and to ask questions so we could clear up a lot of misconceptions. They've learned to be supportive and work hard to understand. I think coming out has helped our relationship in the long run. We're all a lot more honest and open with each other.

*Statement* ¶ TOPHER: The one thing we agree upon is the amount of work it has taken to stay together. Looking back, it seems like we were very young to be committed to each other. We didn't know who we were or what we wanted and we argued a lot about everything. ¶ Sometimes it was just too much to try to find one's self, juggle work, attend school, and build a relationship all at once. We're lucky we have a lot of common interests and beliefs. It helps hold us together during the rough times. We still, and probably always will be, learning to compromise and appreciate the other for who he is. But as we reach thirty, things seem a lot more clear. ¶ Joe's always been much more of a black-and-white person: things are either great or rotten. He's a perfectionist, a worrier, and wants too much control. But I adore him with all my heart. ¶ JOE: Topher's very even. He's satisfied easily and has much more patience than I. He's not very spontaneous and avoids dealing with problems, but he's kind of like my rock or stabilizer. I don't know what I would do without him.

### "TOPHER"

**BORN:** *September 17, 1964, Richmond, Virginia*    **RESIDENCE:** *New York, New York*    **EDUCATION:** *B.A., Psychology, M.T., Teaching (Special Education), Virginia Commonwealth University*    **OCCUPATION:** *Teacher*

### JOE

**BORN:** *March 24, 1965, Norton, Virginia*    **RESIDENCE:** *New York, New York*    **EDUCATION:** *B.F.A., Communication Design, Virginia Commonwealth University*    **OCCUPATION:** *Designer*

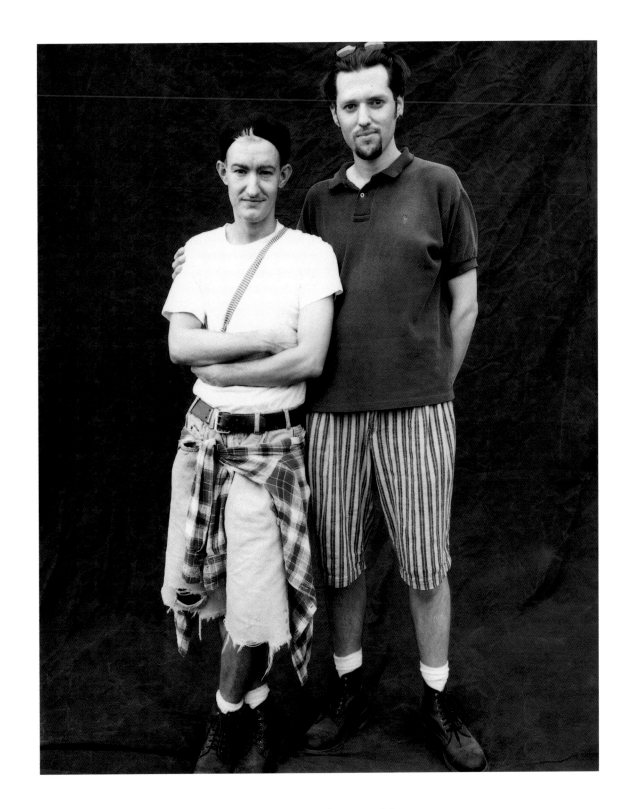

# Billy Lenihan & Sal Lenzo

## ONE AND A HALF YEARS TOGETHER

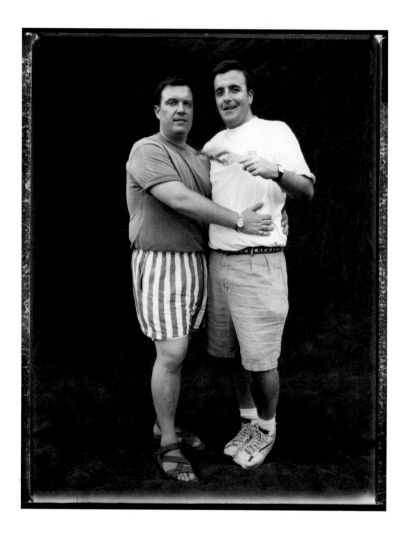

***How We Met*** ¶ We met at a party Memorial Day 1993.

***Coming Out*** ¶ BILLY: I gained a sense of validation, and lost some friends. Most of all I regret not being honest with myself and my family sooner. ¶ SAL: Once I realized who I was, it put so much in perspective. I felt so much better knowing who I was.

***How We Spend Our Free Time*** ¶ BILLY: Most of my free time is spent with Sal. We're best friends. ¶ SAL: We try to spend as much time together as possible because we enjoy each other's company very much.

**BILLY**

**BORN:** *September 6, 1965, Manhattan, New York*   **RESIDENCE:** *Manhattan, New York*   **EDUCATION:** *Studied photography*   **OCCUPATION:** *Salesman*
**WHEN OUT:** *Age twenty-four*

**SAL**

**BORN:** *October 1, 1957, Staten Island, New York*   **RESIDENCE:** *Manhattan, New York*   **EDUCATION:** *Studied fashion design*   **OCCUPATION:** *Visual-presentation director*
**WHEN OUT:** *Age twenty-one*

# Helen C. Buschmann & Maureen O'Brien

## FIFTEEN YEARS TOGETHER

*How We Met* ❡ We worked in the same hospital.

*Statement* ❡ MAUREEN: The greatest gift I gave to myself was coming out to my family in 1971. My brothers and sisters were all supportive and after a while so were my parents. Having family love and support made my life and life-style much easier. My close friends growing up were also gay and lesbian (funny how we sought each other out). I've never really felt closeted. However, I don't necessarily tell new friends I'm a lesbian right away. I prefer to let people get to know me and my partner, and if it's appropriate then I'll tell them. ❡ Helen has been the greatest person and the best influence in my life. She is supportive, open, loving and most of all, still crazy about me. I don't regret my past relationships because I realize only too well how wonderful my life is now with Helen. ❡ My dream for us is to stay healthy and grow old together, to raise our animals and maybe turn our home into a retirement home for our sisters and friends. ❡ HELEN: I love being gay. I couldn't imagine being anything but gay. It's just the way it's supposed to be. It's me.

*How We Spend Our Free Time* ❡ We enjoy going to different events, taking care of our home, craft fairs, weekend trips, shopping for home, rollerblading, and golfing.

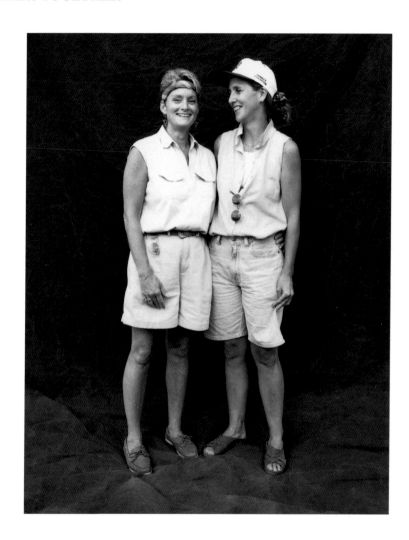

### HELEN
BORN: *March 1, 1953, Rockville Centre, New York*   RESIDENCE: *Northport, New York*   EDUCATION: *A.A.S., Nursing and Surgical Technology*
OCCUPATION: *Registered nurse/operating room*   WHEN OUT: *Summer 1978*

### MAUREEN
BORN: *November 6, 1950, Brooklyn, New York*   RESIDENCE: *Northport, New York*   EDUCATION: *B.S.N.*   OCCUPATION: *Registered nurse/open heart unit*
WHEN OUT: *September 1969*

# Robert Dawalt & David R. Leachman

## FOURTEEN YEARS TOGETHER

*How We Met* ❦ DAVID: We met in the fall of 1980. We were singers in the chorus of an off-off-Broadway musical called "Christmas Rappings."

*Coming Out* ❦ DAVID: Coming out finally made sense of a long personal struggle to understand my longings and interests. Neither my family nor many friends were particularly surprised by the time I came out to them. However, it made returning to the ministry after an educational leave impossible. ❦ ROBERT: Coming out provided an amazing sense of wholeness and centeredness, no more hiding. ❦ Finding a lover and coming out were intermixed. I am close to my family, which forced me to include them, regardless of the possible risk. It made my life easier—no lying. They accepted David, which allowed me to stay close and involved in my family's life. ❦ I did not come out on the job, but I don't hide David's presence either. ❦ We go to a church that allows us to celebrate being a couple.

*Statement* ❦ ROBERT: Finding a mate was right for me. The Doris Day movies of my youth didn't make sense until I met David—then leaving everything behind for Mr. Right rang true. Because I couldn't admit that I might be gay and thought there was no such thing as gay coupling, I wasted my college years trying to date. When I met David I had enjoyed clandestine sexual adventures, but wasn't comfortable telling most people about them or my feelings of excitement. After I met David love was so strong that nothing else mattered and I jumped in with both feet and other body parts.

*How We Spend Our Free Time* ❦ Taking photographs, visiting relatives and friends, and going to the beach.

## ROBERT

**BORN:** *July 22, 1948, Elizabeth, New Jersey*   **RESIDENCE:** *Jersey City, New Jersey*   **EDUCATION:** *B.A., Tulane University*   **OCCUPATION:** *Computer consultant*
**WHEN OUT:** *After I met David in 1980*

## DAVID

**BORN:** *September 18, 1944, Des Moines, Iowa*   **RESIDENCE:** *Jersey City, New Jersey*   **EDUCATION:** *B.S., Iowa State University, M.Div, St. Paul School of Theology*
**OCCUPATION:** *Telecommunications manager*   **WHEN OUT:** *To self, 1972; publicly, 1976*

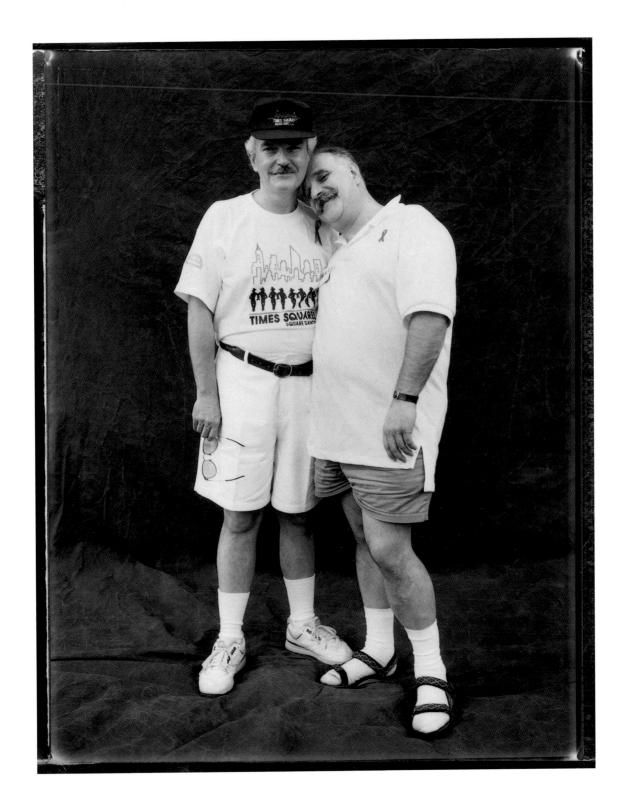

# Sheila Donahue & Betsy Emmons

## ONE AND A HALF YEARS TOGETHER

***How We Met*** ❡ SHEILA: Someone pointed out Betsy to me. We were discussing a committee in need of a member. I took one look at her on the panel and decided to sit on that committee. I managed to give Betsy my phone number by including it in a report I submitted. I hoped we might get to know each other through the project. Before I knew it, though, Betsy called to ask me out. One thing led to another and eighteen months later we're still together. The amazing thing is how new it still feels! ❡ BETSY: After waiting so long for this wild magical moment, one February evening in Portland we were on our way to a meeting, but we went to Paris instead.

***Coming Out*** ❡ BETSY: Coming out has taken me places I wouldn't otherwise have gone. It's made my life political in a grass-roots sense and controversial in its fabric. It's gifted me with a kinship among people from all walks of life, all shades of style and sexuality. I've grown into my own adulthood as part of and a participant in an unprecedented social movement and life-style. Most importantly, coming out set free my sexuality and my life force—it was the first in a long sequence of events that led me to Betsy! I ended my heterosexual marriage. I moved to Portland. I got sober and drug-free. I found exceptional friends and I finally found freedom and my own strength and power.

***Statement*** ❡ SHEILA: I would characterize our relationship as passionate. Betsy and I are considerably different yet we're very connected. This keeps things pretty well stirred up between us!

***How We Spend Our Free Time*** ❡ BETSY: Being a mother of three boys makes free time precious. I like to experience fun like gazing into Sheila's eyes, motorcycling, music, worshiping nature (especially the beach and ocean), hanging out with my friends, drinking coffee, gardening, fishing, camping, hiking, working out, and bodybuilding. I have decided to compete in the 1998 Gay Games physique competition in Amsterdam.

### SHEILA

**BORN:** *January 12, 1953, Lewiston, Maine*   **RESIDENCE:** *Portland, Maine*   **EDUCATION:** *B.A., Psychology, A.A.S. Electronics*
**OCCUPATION:** *Telecommunications technician*   **WHEN OUT:** *1977*

### BETSY

**BORN:** *May 18, 1960, Coburg, Germany*   **RESIDENCE:** *Portland, Maine*   **EDUCATION:** *B.S., Psychology/Rehabilitation*   **OCCUPATION:** *Licensed social worker*
**WHEN OUT:** *1984, after the birth of my second son*

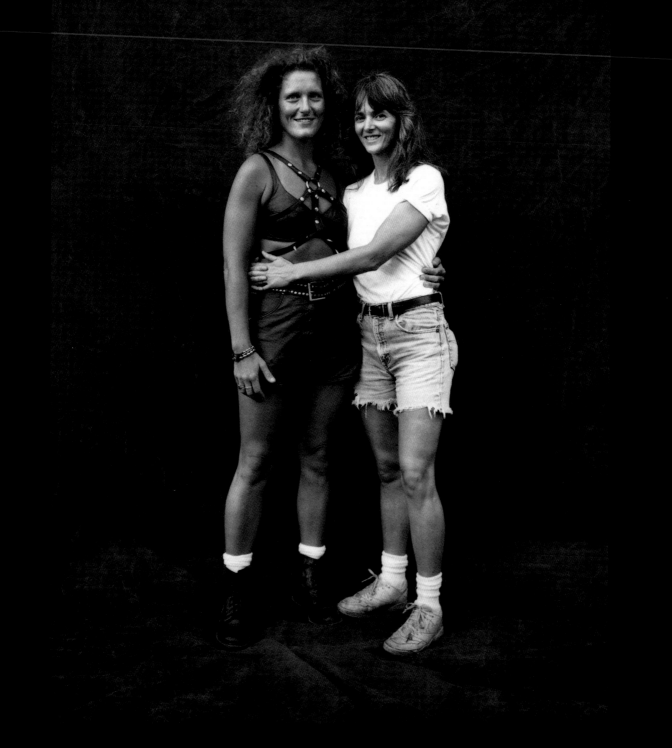

# John Joseph Coniff, Jr. & Wayne Thrash

## ONE YEAR TOGETHER

***How We Met*** ¶ WAYNE: I first met John at a Christmas party three years ago. I remember him as cute and flirtatious, and being attracted to him. I met him again on the day of Denver's PrideFest in 1993. At first I didn't remember him, but as we talked it came back to me—I remembered our first meeting and how I had thought "Ooh what a cutie! I'd like to know him!" ¶ JOHN: Wayne and I celebrated our first anniversary of beautiful lovemaking at the Stonewall 25 events. We celebrated our first anniversary on July 4. The next day I went with him to his family reunion where he proudly introduced me as his boyfriend! ¶ WAYNE: We've been dating for over a year. On our first real date we had a wonderful time watching fireworks in downtown Denver. We smooched and hugged without concern for those around us. I'll never be able to watch fireworks again without feeling my love connection to John.

***Coming Out*** ¶ JOHN: When I was fifteen years old I looked up "gay" in the phone book , called the number, and asked if they had a youth group. ¶ WAYNE: I personally look at coming out as a life-long process of continuous self-exploration. Most people I know define "coming out" as acknowledging one's attraction to the same sex; this happened for me in the summer of 1969 when I was sixteen. I had had sex with boys before this but considered it to be "fooling around" and did not conceive of it as a way of life. When I was sixteen I met a boy and found myself feeling LOVE, the kind songs and poems and movies speak of, and it totally

changed me. ¶ WAYNE: It totally changed me. I finally felt like I was OK. Before this, I thought these sexual feelings I had and the sexual things I did with other boys was this dirty thing that I could never tell anyone about and that I would probably always do, keeping it a dark secret in the context of a life of marriage and children and career, etc. But when I found myself feeling love, I realized that this part of me was connected to my heart and deeper self. I remember thinking : This (loving someone) is totally good, this is of God, this is one of the most important things I was put on Earth to do. ¶ JOHN: I came out so early that my adult persona is that of a gay man. My immediate family has been wonderfully supportive. ¶ Coming out is an ongoing process for me. I came out in high school while attending weekend youth meetings. I had just left one school in the middle of the year to attend another and found myself among strangers. I subsequently turned for support to gay friends I had met in these meetings. Unfortunately, this motley band of dropouts and older guys was much more attractive than high school; my grades suffered. I worked hard for years to get back into school, to learn how to study, and to get myself into a good college. ¶ Religion? I practice Hichiren Shoshu Buddhism, a philosophy based on cause and effect: words, thoughts, and deeds are causes and we experience their effect in our lives as karma. Biology, social conditioning, etc. It is my karma and I can create value with being gay or I can be miserable. I choose happiness. ¶ Colorado's Amendment 2 forced me out of the closet in ways I

never imagined. I currently work in a bookstore and find myself as the only openly gay man in a place that is in many ways the intellectual heartbeat of the city. It was my duty to be out, to get involved in the political scene and to fight for my rights with the support of the bookstore behind me. ¶ I also write book reviews for our gay and lesbian community center. More than anything else, this activity has really helped me reflect on my identify as a gay man. Prior to writing the reviews I never read gay literature. Now I know that gays and lesbians have a wonderfully rich heritage and culture; it is a true joy to experience our lives in literature. ¶ WAYNE: I felt really wonderful. I loved myself for the first time. However, I was living as a teenager in a blue-collar neighborhood and going to a high school in the Midwest in the late 1960s and I knew no other person who felt this way. I was isolated and alone. My family told fag jokes and talked about "those perverts." I remained isolated until I was able to meet other out queers. Now I am out as I can be. I love myself including my queerness. I am working to distinguish between closet behavior motivated by my own irrational fear versus that motivated by real danger. When it is my fear, I work to push myself to be more out. When it is real danger, I pay attention! Life is too short to spend hiding, and the rewards in terms of human connection are too great to not give myself every opportunity to have honest relationships.

***Statement*** ¶ WAYNE: I really love John. I also like him and have fun with him. I am anxious for us to

**JOHN**
BORN: *January 11, 1967, Colorado Springs, Colorado*   RESIDENCE: *Colorado Springs, Colorado*   EDUCATION: *B.A., History, Colorado College*

**WAYNE**
BORN: *May 19, 1953, Akron, Ohio*   RESIDENCE: *Denver, Colorado*   EDUCATION: *B.S., M.S., Nursing*   OCCUPATION: *Psychotherapist / HIV consultant*

live in closer proximity so we can see what that is like. ❡ I have asked him to consider living together, which is a big step for me. The last time I tried this twenty-three years ago, it was a disaster. But I feel I have learned what I can as a single person and am ready to learn those things one can only learn in intimate relationships. He may not be ready for this and I will be patient. Bottom line: I love him and know that he will always be in my heart and life.

*How We Spend Our Free Time* ❡ JOHN: I currently commute on my days off to Denver—some sixty miles—to be with Wayne and work on our relationship. I am beginning a job-hunting process so I can move to Denver and date him on a daily basis. (Our trip to Stonewall was part of a three-week vacation, the longest continuous time we have spent together. I figure if we can spend three weeks in a car together, we can probably live in the same city.) Otherwise, I read, bicycle, collect eighteenth-century antiques, write and "do art." ❡ WAYNE: I don't have a lot of free time given the demands of my work life right now, but I spend as much of it as I can with John. It's difficult because he lives so far away and our days off are not the same, but I go to visit him or he comes to visit me. Together we watch movies, spend time with friends and with his family, whom I really like, cook for each other, shop together, walk around and look at things and talk about our separate and connected journeys through life. And then there is that physical connection! Myself, I read, exercise (I'm forty-one and I want a lot more years of feeling good in this body), spend time with friends, travel and think incessantly about everything.

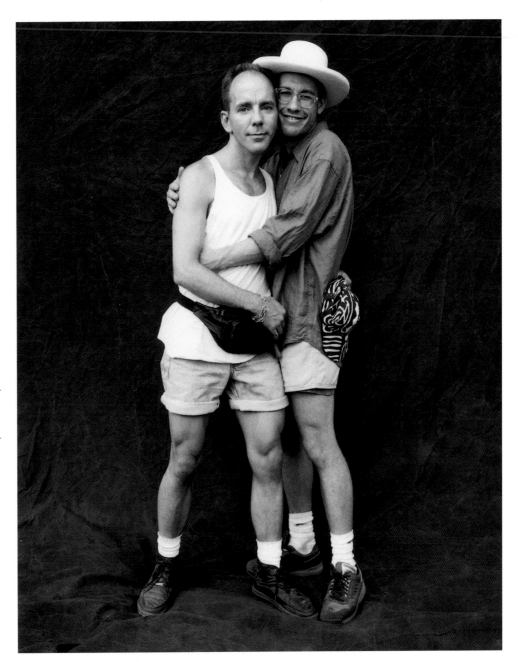

# Patty Gibson & Lisa Sbrana

## SEVEN YEARS TOGETHER

***How We Met*** ❡ We met in 1987 when we worked together at a shelter for homeless women and children in Los Angeles.

***Coming Out*** ❡ PATTY: Coming out was definitely a good move. Of course, it hasn't been as profitable for me as it has been for Melissa Etheridge. But then, we're not as sexy as she is!

***How We Spend Our Free Time*** ❡ We enjoy exploring New York City and the world, shopping, and watching Melrose Place.

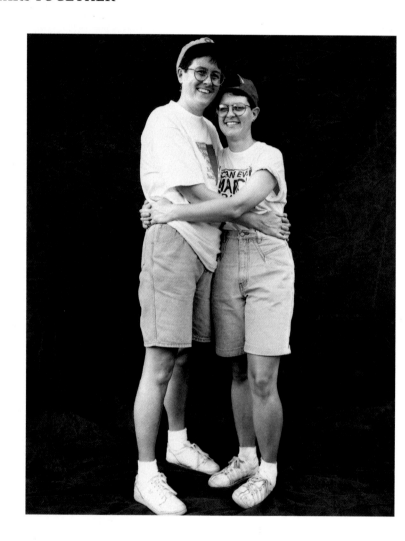

**PATTY**

**BORN:** *September 30, 1960, California*   **RESIDENCE:** *New York, New York*   **EDUCATION:** *B.A., Sociology and Accounting*   **OCCUPATION:** *Nonprofit accountant*   **WHEN OUT:** *1986*

**LISA**

**BORN:** *January 24, 1965, California*   **RESIDENCE:** *New York, New York*   **EDUCATION:** *J.D.*   **OCCUPATION:** *Public-interest lawyer*   **WHEN OUT:** *1987*

# Scott D. Deeck & Patrick Rochford

## EIGHT AND A HALF YEARS TOGETHER

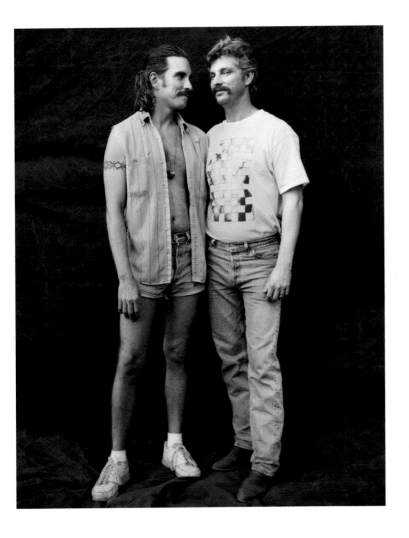

***How We Met*** ❡ SCOTT: We met at a Jacksonville nightclub—College Station. We made a date to meet two nights later, January 28, 1986, my birthday, and we've been together ever since. ❡ PATRICK: It was love at first sight.

***Coming Out*** ❡ SCOTT: I realized that I could be open and honest about my life. My parents still loved me, my friends still talked to me, and my life didn't come to an end. ❡ PATRICK: Surprisingly, not much. I had an older brother pave the way with the family. Friends are still here—some knew before I did.

***How We Spend Our Free Time*** ❡ SCOTT: I enjoy reading, computers, exercising, singing with the Jax Gay Chorus, and spending time with Pat. ❡ PATRICK: I enjoy our pets—two Great Danes, a cat, a bird, and a Ball python—and spending time with Scott, as much as our schedules permit.

### SCOTT

**BORN:** *January 28, 1962, Baltimore, Maryland*   **RESIDENCE:** *Jacksonville, Florida*   **EDUCATION:** *A.S., Accounting*   **OCCUPATION:** *Accountant*
**WHEN OUT:** *May 1980*

### PATRICK

**BORN:** *August 4, 1961, Jacksonville, Florida*   **RESIDENCE:** *Jacksonville, Florida*   **EDUCATION:** *Some college*   **OCCUPATION:** *Night supervisor and dispatcher*
**WHEN OUT:** *August 1982*

# Michael Vincent Susi & Sean Sawyer

## TWO YEARS TOGETHER

***How We Met*** ¶ SEAN: We first saw each other on the Bronx-bound No. 1 train, although I remember seeing Michael once before on campus at Columbia University. We cruised each other on the train, but I got off at 110th Street and Michael continued uptown, claiming later that he wasn't about to be picked up on the subway. We finally met about a week later on a Friday—August 28, 1992—when I was walking past his office window on campus. He raced to the opposite end of the building so he could nonchalantly walk by me. We couldn't stop looking at each other and we suddenly started talking (about what, we never can recall). Within ten minutes, I got him to my place for coffee. Not falling for this pretense, he claimed he had to get back to work. We exchanged numbers and I said I'd call him after the weekend, but before the day was over we had our first date and were making future plans. We haven't been apart much ever since. ¶ One of the strongest things about our relationship is how much we just enjoy being together and doing things, even if it's something one of us is less excited about. What's more, we build on each other's interests and develop them in ways we might not have on our own. For instance, we both love cities and their architectural history. Being a graduate student, I'd never taken the time to explore New York much beyond the areas I frequented. Michael is a New Yorker to his core and introduces me to new neighborhoods and landmarks, either through his collection of turn-of-the-century postcard views and related ephemera or by bicycle or train. On the other hand, Michael credits me with convincing him that other places besides New York are worthy of appreciation and so we have planned trips to Edinburgh and London, Montreal and Nova Scotia.

***Coming Out*** ¶ MICHAEL: I came out to myself at about four or five. I remember because at the time I had a wild crush on Bob McAllister, host of a local New York kids' show *Wonderama,* though it was probably a few years later when the words "homosexual," "gay," or "fag" were already known to me and the concept behind the epithet was already well embraced. In fact, I always took great pride in being different and special in this way, never once thinking there was something wrong with me. I intrinsically knew that this was one more thing I would need to be "grown up" before I could explore. ¶ At the same time, I knew it would be harder for me to be accepted once people knew. So I had to be doubly impressive, which for me—growing up in Brooklyn and despising most organized sports—meant one thing: excelling in school well enough to get out of Brooklyn. This I did and along the way learned the things I needed to know about prejudice and tolerance and about being gay, something I was really lusting to be. With the help of the Brooklyn Public Library, where I read everything from *The Dave Kopay Story* to John Rechy's *City of Night,* and several gay and lesbian (and many gay- and lesbian-friendly) teachers in the public-school system, I forged the self-esteem and identity that I still carry with me today as a gay man. (Thank you Ms. Meagher.) ¶ I've never had anything but positive reactions from people I've told (friends and teachers in junior-high and high schools; family and everyone else during my first year of college). Of course there were some tears along the way, shed by my twelfth-grade English teacher, who worried about what a difficult life I'd chosen for myself. I hope she sees this book if only to find out how wrong she was. ¶ SEAN: It's hard to say exactly when I first came out. I had my first, long-awaited sexual experience with a man during my freshman year in college. After that it just seemed necessary that anyone close to me should know that I was gay. It took me three and a half years to summon up the courage to come out to my parents. Even now it seems like there's always an opportunity to come out farther. Coming out is a lifelong challenge in my opinion. ¶ Coming out was, is, and always will be a powerfully positive experience for me and the ones I love. Before, I felt like no one really knew me, even my parents. It hasn't always been a smooth or easy process, especially with my family, but the truthfulness and integrity gained is well worth any temporary pain. Most importantly, the greatest effect of coming out has not been on my relationship with others, but on my relationship with myself. Now I know who I am.

**MICHAEL**

**BORN:** *April 18, 1963, Brooklyn, New York*  **RESIDENCE:** *Manhattan, New York*  **EDUCATION:** *B.A., Columbia College, M.A., M.Phil., Social Psychology, Columbia University*  **OCCUPATION:** *Director of Planning, Arts and Sciences, Columbia University*

**SEAN**

**BORN:** *March 17, 1966, East Haven, Vermont*  **RESIDENCE:** *Manhattan, New York*  **EDUCATION:** *B.A., Princeton University, M.A., M.Phil., Ph.D. candidate, Architectural history, Columbia University*  **OCCUPATION:** *Architectural Historian, Arts and Sciences, Columbia University*

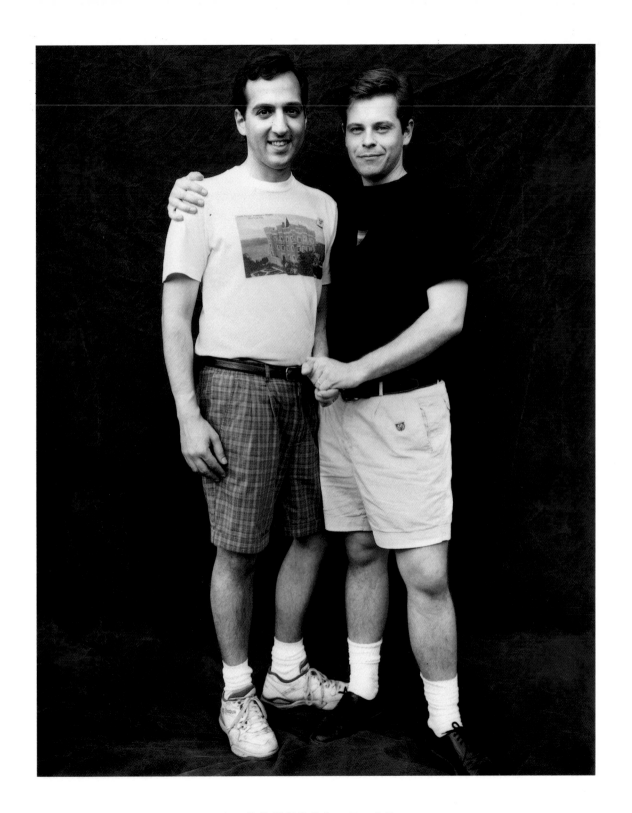

# Danny R. Alvarado & Tony J. Gonzales

## THIRTEEN YEARS TOGETHER

*How We Met* ❡ DANNY: Although we had seen each other briefly at a party, it wasn't until August 16, 1981, that a friend introduced us at Griffith Park ("The Meet Market"). We were not looking for any kind of a relationship that afternoon but made a date to see each other the next weekend. We got together and have never been apart since.

*Coming Out* ❡ DANNY: When I first came out, it did not affect my friends because most of them were gay. Those that were not gay just didn't say anything about it. I am still in the closet as far as my present employer and coworkers are concerned, because I have had unpleasant experiences with previous employers who found out. But coming out with my family, well, that's a different story. The part that hurt the most was that my mom did not speak to me for almost a year. One of my sisters told her she was going to hell because I was gay. But today all is changed and my family accepts me and Tony and gives us the respect as a couple that we deserve. As far as religion goes, I am Catholic and I believe God loves all people no matter what sexuality they are. ❡ TONY: Coming out gave me a feeling of relief, finally knowing why I was different. As for religion, I was raised a Catholic but never felt good about it; when I came out, knowing that the church does not approve of homosexuality just drove me further away. I am very lucky that my family accepts me for being gay. My mom treats Danny like another son.

*How We Spend Our Free Time* ❡ DANNY: Although my free time is limited due to school and work, I enjoy going out dancing with Tony and friends. I also enjoy spending time with my family, working on my truck, running with my dog Kia, and playing with the computer. ❡ TONY: We enjoy going out to clubs and meeting with friends (although most of our close friends are gone now). I also enjoy spending time with my six-year-old nephew, Anthony Daniel, who my sister named after me and my lover.

### DANNY

**BORN:** *January 26, 1962, East Los Angeles, California*   **RESIDENCE:** *Bellflower, California*   **EDUCATION:** *A.A., Electronics and Computer Science, A.S., Automation Technology, B.S., Electronic Engineering*   **OCCUPATION:** *Field Engineer, Eastman Kodak Company*   **WHEN OUT:** *Summer 1979*

### TONY

**BORN:** *December 20, 1957, Los Angeles, California*   **RESIDENCE:** *Bellflower, California*   **OCCUPATION:** *Nutrition Coordinator*   **WHEN OUT:** *1977*

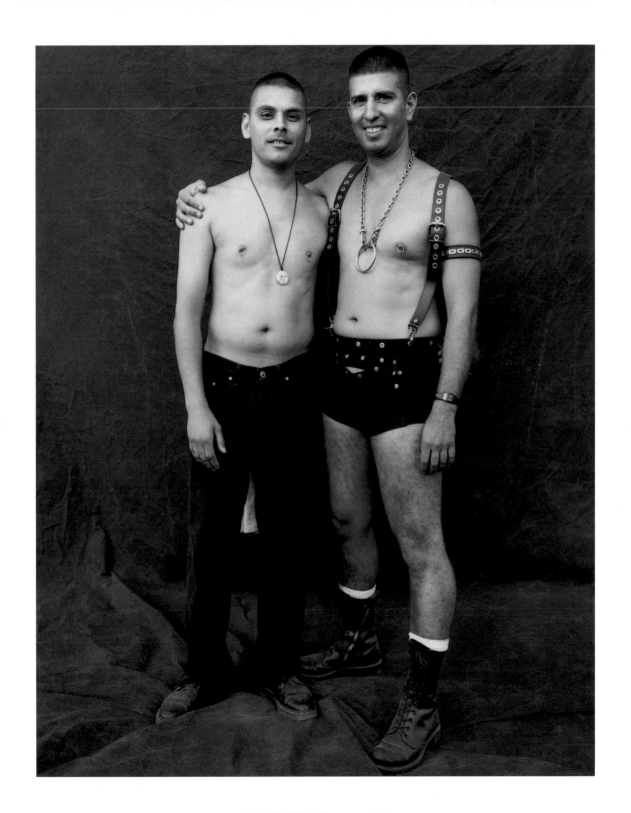

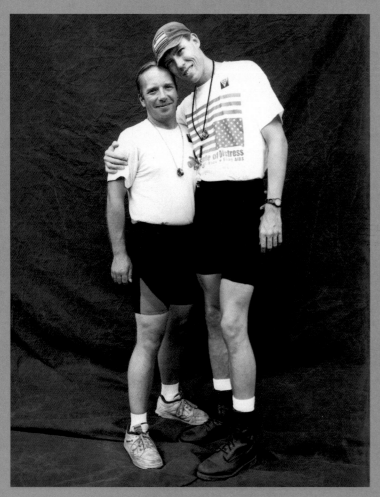

*Roy A. Peterson & William McNeel*

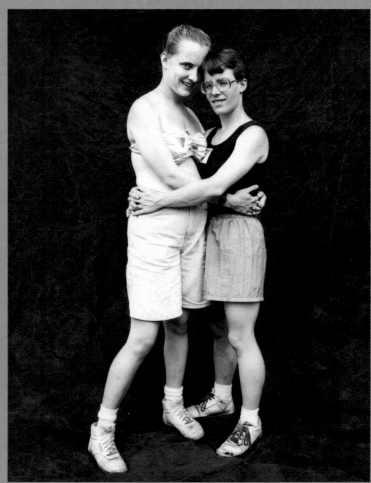

*Bethann Manley & Jo Ellen Anderson*

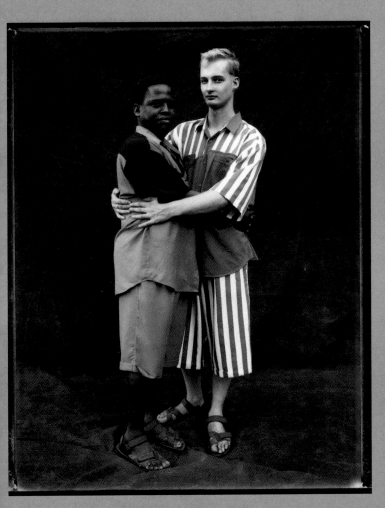

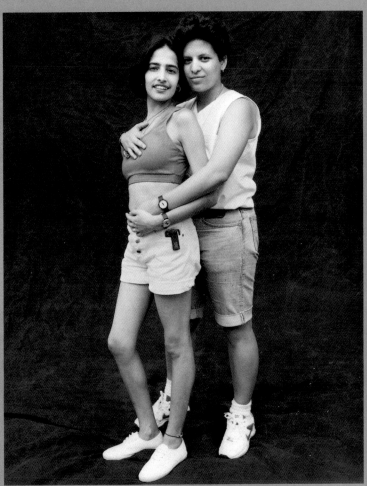

Jerry J. Tew & Terry Bordley

Violette & Norma Vargas

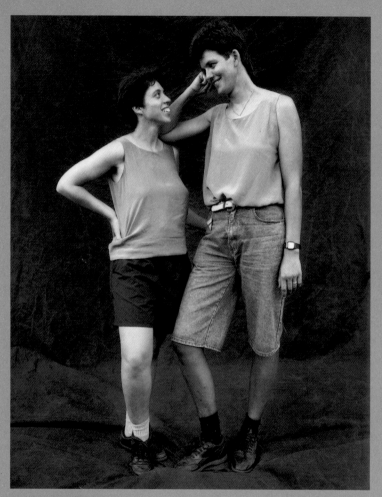

*Monica Rook & Laura Davis*

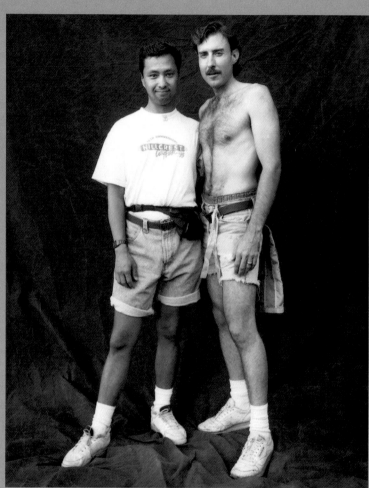

*Michael Lutts & Alexander Willis*

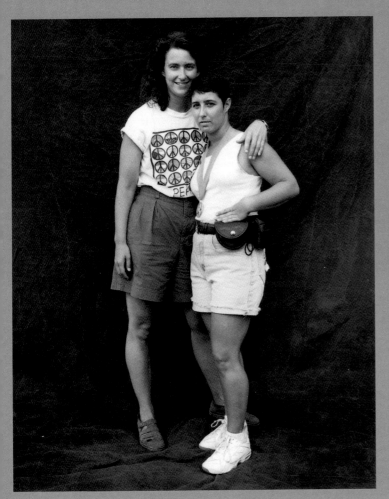

*Lori Shorin & Pamela D. Coleman*

*Jay Geddis & Mark A. Hammer*

# Joseph Harding & Tom Cannon, Jr., with Theopolis

## THREE YEARS TOGETHER

*How We Met* ❡ At Wigstock.

*Coming Out* ❡ TOM: Coming out was the best thing I ever did—one less burden. My sisters agree that among the boyfriends and husbands in the family, mine is number one! Coming out enabled me to live my life more completely. Joseph and I work very hard at our relationship. Nothing comes easy, but love makes it all worthwhile.

*Statement* ❡ Contrary to the homo-media ideal, a gay relationship is more than a black-and-white photograph of two buffed, half-naked men holding each other. Many couples fail to succeed when reality enters the picture. Togetherness is very hard work; many hours of sweat and tears go into a lifetime commitment of happiness. It is foolish to believe that a relationship should be effortless. An untended garden will never yield the rich regards of one that is lovingly cultivated. Joseph and I come from different backgrounds: while Joseph has never discussed the details of his homosexuality with his parents for because it's just not done, while I am "out loud and proud." However, happily, our families have embraced our respective mates. I was given my own engraved placecard at the holidays, while Joseph was showered with PDAs. We have become a permanent part of each other's familial tapestry: tales and traditions, triumphs and tragedies are openly shared at the table.

*How We Spend Our Free Time* ❡ JOSEPH AND TOM: Sleeping, reading, living the glamorous life, playing with the dog, fixing up our house upstate. ❡ THEOPOLIS: Sleeping, playing with the boys, eating, exploring upstate.

### JOSEPH

**BORN:** *April 18, 1959, New York, New York*    **RESIDENCE:** *New York, New York*    **EDUCATION:** *B.A., Medieval History, Fordham University*
**OCCUPATION:** *Director of Legal Services for the Forrest Edwards Group*

### TOM

**BORN:** *January 31, 1966, Jersey City, New Jersey*    **RESIDENCE:** *New York City*    **EDUCATION:** *B.S., Biology, Trenton State College*    **OCCUPATION:** *Magazine Editor*

### THEOPOLIS (TEDDY) BARRA CANNON-HARDING (THE DOG)

**BIRTH:** *Date unknown, in New York City*    **RESIDENCE:** *New York City*    **EDUCATION:** *Street Smart*    **OCCUPATION:** *Security officer*

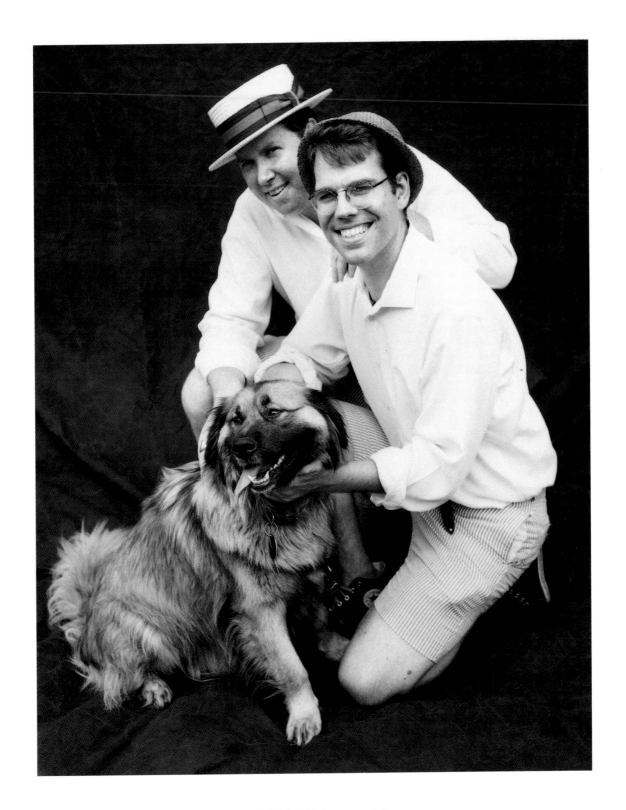

# Keith J. Olexa & Michael Ryan

## TWO YEARS TOGETHER

*How We Met* ¶ MICHAEL: Keith and I met at the 1992 New York City Pride Parade (somewhere between Twentieth and Thirtieth Streets on Fifth Avenue). I had come down to New York with some friends. I didn't want to go alone on the day of the parade, so I marched with them even though I didn't belong to their group. Somewhere around Thirtieth Street, I was handed the water bottle to carry. A little later Keith came over to ask for a drink. We started talking, talking some more, talking some more, went out to dinner together that night, and then had a wonderful night together. The next day I left town (to go back upstate to Ithaca where I lived at the time). Between visits and long phone calls we managed to build a relationship that has lasted two and a half years and gets stronger every day.

*Coming Out* ¶ KEITH: In college I made it a point to find a very liberal school. Purchase has a liberal-arts curriculum and an unofficial reputation for attracting gays. A lot of fringe people went there, people who for one reason or another didn't fit in with the high-school norm. I came out completely several weeks before the end of the semester and met my first boyfriend on the heels of the announcement. Things didn't work out between him and me, but the experience and the sense of acceptance and camaraderie I felt I have never forgotten. ¶ KEITH: Friends were the easiest. I have always attracted a circle of friends both jaded and strange—jaded enough to turn a deaf ear to the voice of mainstream rhetoric, strange enough to view the wonders

of the world with multifaceted eyes, and ideals. All of them are smart as well. A gay man in their midsts was downright prosaic. Not one of them reacted with either shock or extreme joy. I might as well have told I was left-handed. The job part is a tiring little nuisance, at times. It's a nuisance because I move so often from store to store, thus I have to come out to a new group of people every six months or so, and the coming-out process is never easy. Some store staff are very supportive, others downright cold. My life is a little rocky and Michael often takes the brunt, for which I'm happy. Family is a cloudy area. I've come out to them. Most stay away but have never directly confronted me about my orientation—especially my father. We have only recently reconciled some old differences but I can't seem to get him to understand my orientation. My brother is the best of the lot. He is my twin, identical and straight as an arrow. ¶ I am a practicing neopagan. I belonged to a wonderful circle for over ten years, one full of people of all sexes, backgrounds, races and orientations. My birth religion was Roman Catholic—a religion I thank for instilling in me an appreciation for things spiritual. I fell out of love with the Church of Christ, harping as it does on the sins of same-sex love. I balked as well at the dogmatism of Catholicism. I needed to feel my religion, to make it work through me. Paganism has taught me to love the earth, love my body, respect power and authority, and to respect love in its myriad forms. It's an experiential religion that promotes love and joy and rejects hate and fear. I felt I was able to choose this religion, to join such a perse-

cuted cause, because, I think, of my place within another persecuted minority: homosexuals. Now I have two closets to come out of, and one is a broom closet. ¶ MICHAEL: About five years ago I came out to most of my friends, and then over the next two years I came out to my family. My coming out has been, in the end, an extremely positive experience. At Cornell, I went through some extremely emotionally trying times, and the memories of those times live within me as a memory of why it is so important for me to be openly out as much as possible. Without a close support network I'm not sure if I could have survived those years. However, my friendships and my relationship with most of my family have been significantly deepened by my willingness to be honest and forthcoming about my life. In many ways, I was and remain, by choice, a loner. However, as I have gotten in touch with my own feelings and my deep feeling for another gay man, I have opened up and significantly deepened my relationships with my friends and most of my family. My mother and I are very close (my father abandoned us when I was very young), and since my coming out she has grown active in organizations such as PFLAG. My mother is willing to push boundaries and, after I was willing to live openly, honestly gay, she supported me. The rest of the family has, for the most part, been accepting as well. And, best of all for me, I have developed over the past few years a deep confidence in the fact that as an openly gay man I can lead a fully satisfying and happy life. Coming out has also strengthened my resolve in my career. I am

### KEITH

**BORN:** *Glen Cove, New York*    **RESIDENCE:** *Astoria, New York*    **OCCUPATION:** *Manager, software retail outlet*

### MICHAEL

**BORN:** *December 12, 1967, Schenectady, New York*    **RESIDENCE:** *Durham, North Carolina*    **EDUCATION:** *Physics, Cornell University, currently Public Policy graduate student at Duke University*    **OCCUPATION:** *Student*

in graduate school studying environmental science and public policy. One of the traps that people who work in public life often fall into is that of being a yes man—someone who all too often says what others want to hear rather than what is true. My commitment towards telling the sometimes unwanted truth about my sexuality has also reinforced my ability to stand firm and to present public issues in an honest manner. I now consider my willingness to be honest about my sexuality an advantage and a tool to show those I work with that I will stand firm in my desire to be truly objective and to say those things that both the public and politicians often wish not to hear.

*How We Spend Our Free Time* ❡ MICHAEL: For Keith and me, free time together is somewhat of an oxymoron. Our time together is usually all too brief. With me in graduate school in North Carolina, this time seems even briefer. The best vacation we've taken together was back to my home state of Colorado. Keith and I stayed with my mother for a couple days and then left to go camping up in the Rocky Mountains. We hiked in the national forest and in the Maroon Bells Wilderness and saw a variety of other sights. For me, the wilderness is like a rejuvenating second home, and I have especially enjoyed the times that Keith and I have experienced it together. Whenever I visit Keith in New York, we generally go to see at least one play. In addition, Keith has a wide base of friends in the area that we often visit. ❡ KEITH: Together, Michael and I like to hike, we are rabid theater buffs, play all sorts of board and card games, go out to dinners, enjoy nature via walking, and driving. When we are more financially able, we'd like to do some traveling. I love to cook, love to write stories, watch cult, old, stupid, and sordid movies of all themes, tweak my computer, work out, and read. Michael and I find ourselves neither bored with each other's company nor helpless on our own. A perfect relationship.

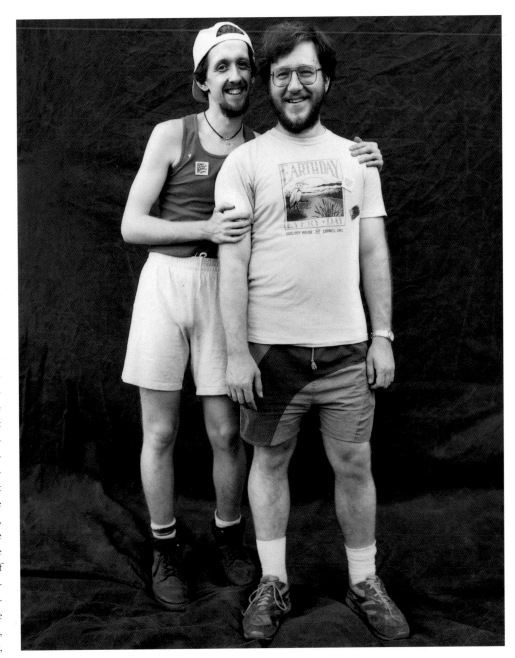

# Brent Chavis & James (Jimmy) F. Orrell

## THREE YEARS TOGETHER

***How We Met*** ¶ JIMMY: Brent and I met in a local bookstore. Ten months prior, I had lost my Puerto Rican lover of seven years, Antonio, to AIDS. It was the most devastating thing that had ever happened to me, and I didn't expect to ever recover or become involved again. Two months after his passing, I decided to memorialize him by continuing his volunteer work at a local agency, ActionAIDS, in Philadelphia. I now have my fifth buddy in the Buddy Program and am a trainer in that same program. When I met Brent, I really had no intentions of having anything long-term, but I guess heaven had other ideas. Even Antonio, as he was passing, had told me not to stay alone and to take another lover. Brent had recently separated from his lover, Luke, a notable in the AIDS community in Philadelphia, but remained good friends.

***Coming Out*** ¶ JIMMY: My initial "coming out" process happened while in college, but I've realized that you are "coming out" for the rest of your life. I have just joined a newly formed Gay/Lesbian group at my company and will be a speaker for that group educating other employees about our sexual orientation. I'm 44, and I never thought I'd have to explain my sexuality to a whole new generation that doesn't seem very sympathetic. ¶ I never really came out to my parents. My father, who passed away 20 years ago, would never have been understanding; and my mother was never really very well so, I saw no point

in putting her through it. However, I know she's aware because she has always asked about my lovers. My friends in college were also gay so I didn't have to come out to them. My most painful moments occurred in high school. I realized my orientation as a sophomore and reached a crisis about it during finals weeks. I was certain I'd have to eventually kill myself. Luckily, as a freshman in college I met someone else who was gay, and I had an overwhelming sense of relief from the isolation.

***How We Spent Our Time Together*** ¶ Luckily, we both worked in the evening, which allowed us to see a good deal of each other, but which doesn't allow much time for socializing. We would go to dinner and the movies, but mostly stay home, watch videos, play with the dogs (Romulus and Luka) and be intimate and domestic.

***Addendum*** ¶ Since the time we were photographed, Brent and I have separated. We had been together for three years. It was a very stormy relationship but also very passionate. We are both Scorpios, so you can imagine the friction, both sexual and emotional! Brent is a Native American of the Lumbee tribe of North Carolina and exceptionally handsome and built. He has the most beautiful black hair and café au lait skin (which drove me wild); Geronimo as a Marine, wow! He used to joke that the Lumbees are known for two things, big thighs and big . . .

well, you get the idea. I was very physically attracted to him. He was a fantastic kisser, something that's a high priority for me in a lover choice. Unfortunately, there were a lot of stresses on the relationship. There was substance and physical abuse, and I think our spiritual backgrounds were very different; Brent was raised Baptist in the country, and I, Catholic in the city. Although neither of us was practicing, I think we had a lot of baggage that got in the way, but I do believe we loved each other. I hope that eventually we can be friends . . . ¶ We were forever squabbling and making up. The squabbling was not enjoyable and got physical on many occasions; but, the making up was wonderful! As I said, we're both Scorpios, ruled by our libidos. We spent a good deal of the time exploring our fantasies, leathersex and role-playing. For my part, I thought we would probably grow old together, happily spending our lives in and out of bed on some bucolic country farm. If he reads this, I would like him to know that I wish him happiness and good health.

**JIMMY**

**BORN:** *October 26, 1950, New York, New York*   **RESIDENCE:** *Philadelphia, Pennsylvania*   **EDUCATION:** *Seton Hall University; University of the Arts, Philadelphia*
**OCCUPATION:** *Computer Graphic Illustrator*   **WHEN OUT:** *1968, the autumn before Stonewall*

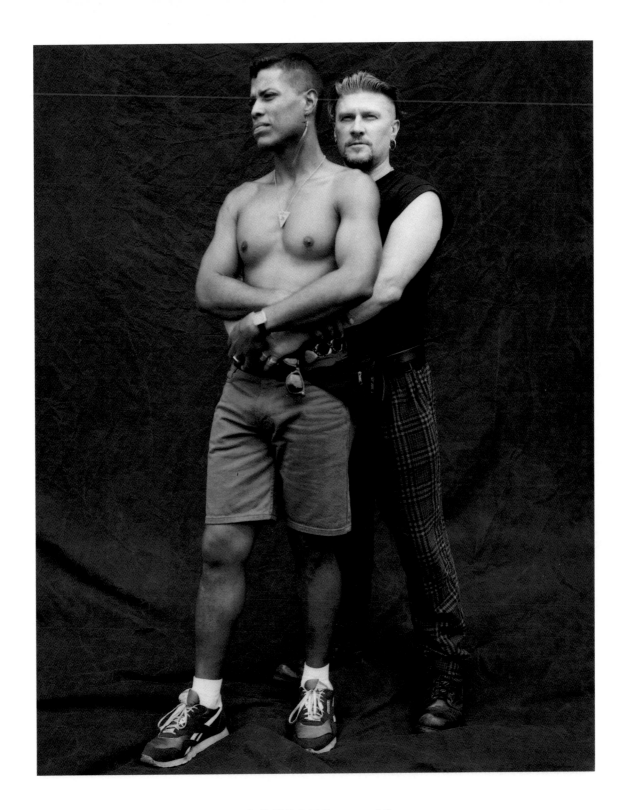

# Ilan Meyer & William Skillman

## NINE YEARS TOGETHER

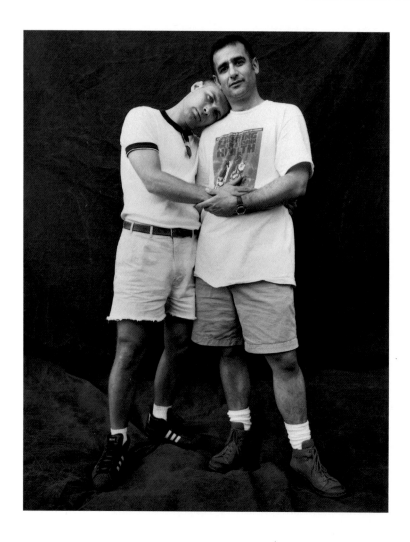

***How We Met*** ❡ We met at Uncle Charlie's Bar in Greenwich Village, New York City.

***Coming Out*** ❡ It makes us who we are.

***How We Spend Our Free Time*** ❡ Reading and listening to music.

### ILAN

**BORN:** *January 26, 1956, Tel Aviv, Israel*　**RESIDENCE:** *New York, New York*　**EDUCATION:** *Ph.D.*　**OCCCUPATION:** *Social scientist*　**WHEN OUT:** *Age twenty*

### WILLIAM

**BORN:** *June 7, 1961, Brooklyn, New York*　**RESIDENCE:** *New York, New York*　**EDUCATION:** *B.A.*　**OCCUPATION:** *Artist*　**WHEN OUT:** *Age sixteen*

# Westley Hartzog & Israel Maldonado

## TWO AND A HALF YEARS TOGETHER

*How We Met* ¶ We met at work through a mutual friend.

*Coming Out* ¶ ISRAEL: My family went into shock and I lost my friends. I came out about three years ago at my job, and it's accepted.

*Statement* ¶ ISRAEL: I planned an elaborate dinner party just to meet Westley. I pulled out all the stops and the party was a great success. At the end of the evening I got to kiss Westley at my·front door and I'll never forget that moment. Right then and there I knew he was the one. He smelled so good, he felt good, he tasted good, and he felt just right. But the feelings weren't entirely mutual. I had to persuade him that I was the only one for him. We make great music together and he makes me happy.

*How We Spend Our Free Time* ¶ Westley spends his free time between New York and South Carolina with family responsibilities.

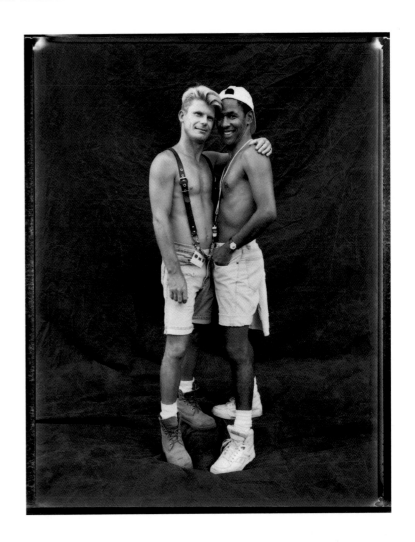

### WESTLEY

**BORN:** *October 7, 1961, South Carolina*   **RESIDENCE:** *Bronx, New York*   **EDUCATION:** *B.A.*   **OCCUPATION:** *Manager, Group Health Service*
**WHEN OUT:** *Age seventeen*

### ISRAEL

**BORN:** *October 28, 1949, Puerto Rico*   **RESIDENCE:** *Bronx, New York*   **EDUCATION:** *B.A., Business*   **OCCUPATION:** *Account representative*   **WHEN OUT:** *Age twenty*

# Patrick Hancock & Glenn Wade

## TEN YEARS TOGETHER

***How We Met*** PATRICK: I was waiting after the local Gay Pride Parade event for the MCC Dallas evening service. He was exploring the city on his second day in Dallas and was checking out one of the local bars. OK, so I was waiting in the bar, but I was on my way to church. GLENN: It was my second day in Dallas. A friend and I had been taking in the sights of Dallas and we stopped for a drink on the strip (Cedar Springs). Patrick came up and introduced himself and we exchanged numbers. We talked over the phone for about a week before getting together for dinner. Four homes, two cats and 10 years later I can't think of life getting any better than this.

***Coming Out*** PATRICK: Coming out should have been a disaster for me, instead it was wonderful. I had all of the conditions that conventional wisdom says portends terrible things; I was raised in a very strict evangelical fundamentalist church, by parents who are both "pillars" of the church and community; almost all of my friends were from the church or the conservative working-class community in which I lived; and I had little or no support mechanism in the gay community. However, after struggling so hard with myself, my own fears and expectations, the much-dreamed response of those around me was anticlimactic. Coming out did not change the people in my life, or their love for me at all, but it did change me. It allowed me to find and fulfill my role as an in-dividual. Once past the largely self-imposed barrier of coming out, I was finally able to focus on what I wanted from life and what I had to offer my society. Before coming out I was a stereotypical overachiever, compensating for terrible feelings of inadequacy and worthlessness. After coming out, I was able to focus toward positive things all of that energy I was using to "pretend." Best of all, because I was out, I met and fell in love with Glenn. He is everything I ever needed or wanted and he makes my life complete and worth living. He is wonderful, and we are near perfect for each other. GLENN: When I came out I was fortunate enough to meet gay people that demonstrated the high moral character that I was taught. Thus, I realized I was not the only gay man in the state of New Mexico, and I could live life as a gay man with dignity and respect.

***Statement*** PATRICK: Coming out is not only important to your individual mental health, but it is vital to your relationship as a couple. The stress of "keeping the secret" is more than a relationship can or should have to bear. It will truly help your love for each other by allowing you to focus on each other and thus grow even stronger. Come out!

***How We Spend Our Free Time*** PATRICK: What little free time we have, we spend traveling, supporting Gay and Lesbian community activities and "working" on our home. GLENN: We love to travel. I enjoy combing through antique shops as I collect old books written between 1880–1930. I particularly enjoy people writing about their travels and adventures during a more romantic time in history. We stay very busy working on our 69-year-old English Tudor home.

### PATRICK

**BORN:** *November 14, 1956, Detroit, Michigan* **RESIDENCE:** *Arlington, Texas* **EDUCATION:** *B.S., University of Texas, Information Systems* **OCCUPATION:** *Union Negotiator for the Association of Professional Flight Attendants* **WHEN OUT:** *1980*

### GLENN

**BORN:** *April 30, 1967, Hobbs, New Mexico* **RESIDENCE:** *Arlington, Texas* **EDUCATION:** *Fine Arts Studies* **OCCUPATION:** *Flight Attendant* **WHEN OUT:** *October 1983*

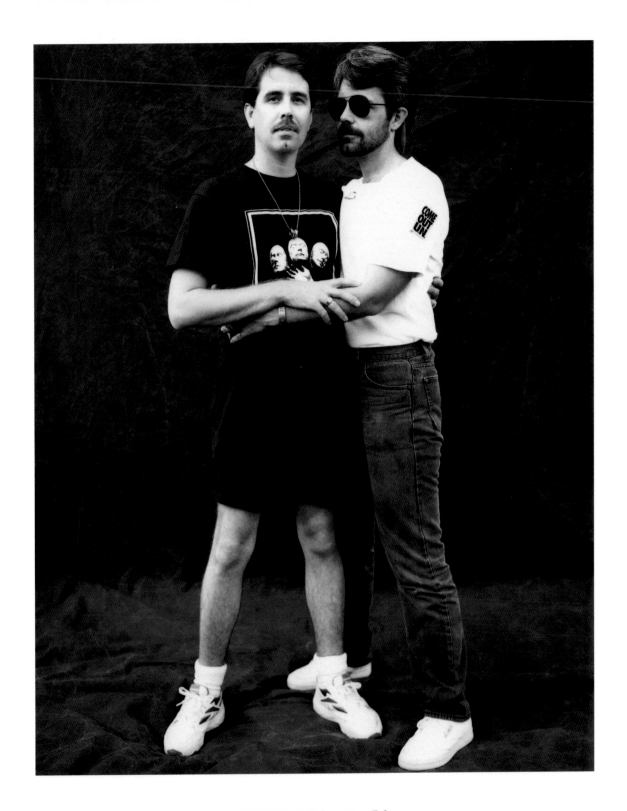

# Steve Curtis & Dave Ruish

## FIFTEEN YEARS TOGETHER

***How We Met*** ¶ DAVE: We met at agricultural school. Steve was showing a dairy heifer and I was showing a beef steer in a competition at the university. That's no bull!

***Coming Out*** ¶ DAVE: It still affects life today in a freeing feeling—no more acting; people either accept and like, or they don't.

***Statement*** ¶ DAVE: We like spending time at our cabin in the woods, in our thoughts, and with our friends, and discovering more of what makes us who we are. We appreciate and share the joy of creating and giving to each other on physical and spiritual levels. ¶ Our relationship over the past fifteen years has taken many twists, turns, and diversions. Many times it was very difficult to maintain communication, friendship, and trust. However, we both separately felt an intense and sometimes unconscious emotional bond with each other that persevered through those difficult times until we both realized almost at the same moment in our lives that we were meant to be together forever. ¶ STEVE: It feels like we are becoming the people that we always wanted to be, the people that we were supposed to be—the little boys who were trapped in the bodies of men doing what was expected of them. We live our lives now from a script that is coming from within us and we have total freedom to play it the way we want—the way it feels right. This freedom comes from the trust and pure connection that allows each of us complete honesty in our expression of emotion, an expression so basic that the other often feels the emotion without exchanging a word. It is a feeling that is so right, so natural, and so easy, that it's scary. We have reached a point in our journeys that allows this freedom and joy and opportunity for continued growth so that now truly the sky is the limit. What could be next? What could be more? This is the feeling of love, unconditional love, alone and together forever.

***How We Spend Our Free Time*** ¶ We like sports, the outdoors, and healthy living, and experiencing every event to the max.

### STEVE

**BORN:** *September 25, 1954, Sarnia, Ontario, Canada*    **RESIDENCE:** *Vancouver, British Columbia, Canada*    **EDUCATION:** *Doctor of Veterinary Medicine*
**OCCUPATION:** *Veterinarian*    **WHEN OUT:** *1979*

### DAVE

**BORN:** *August 2, 1955, Toronto, Ontario, Canada*    **RESIDENCE:** *Vancouver, British Columbia, Canada*    **EDUCATION:** *Doctor of Veterinary Medicine*
**OCCUPATION:** *Veterinarian*    **WHEN OUT:** *1977*

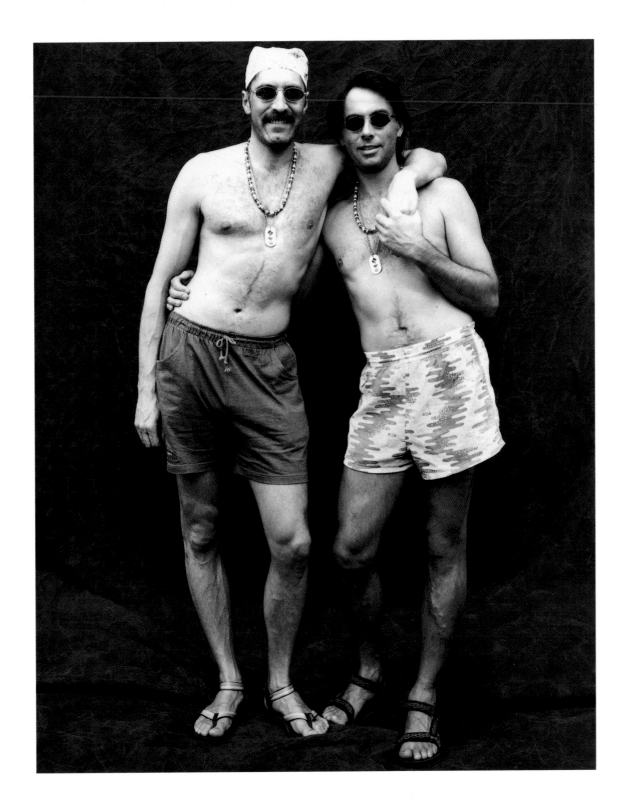

# Betty A. Piazza & Margaret Pucci

## TEN YEARS TOGETHER

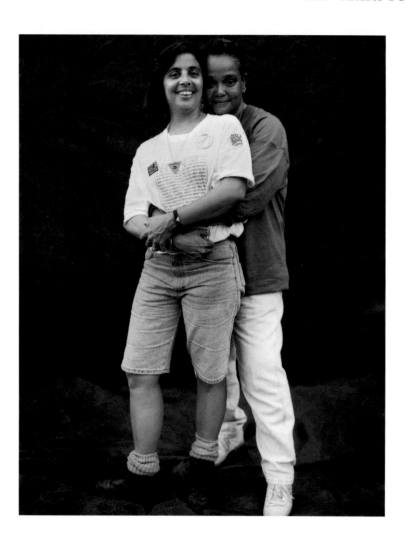

***Coming Out*** ❡ BETTY: Family, ok; friends, fine; job, fine; religion, I am no longer a practicing Catholic. ❡ MARGARET: My family had/has a hard time with my choice. True friends have grown with me. I fought a six-year custody battle.

***Statement*** ❡ BETTY: We have a twelve-year-old son, Anthony Louis. We also have two grandchildren, Michael (three years old), and Marguez (almost one). I have a wonderful daughter, Alicia (twenty-seven years old). I sincerely hope the day will come when people will realize that there is more to us than just the sex aspect. We are all the same, straight or gay. ❡ MARGARET: Being a lesbian, I have learned that all "men" are not created equally. Children are taken from their homosexual parents (even in 1996). We still lose jobs and housing when a partner dies. I hope the world is more accepting in the future. Being a mother, I have learned the joys of unconditional love.

***How We Spend Our Free Time*** ❡ BETTY: Visiting friends, reading, movies. ❡ MARGARET: Enjoying Anthony Lewis, cooking, visiting, or entertaining friends.

**BETTY**

**BORN:** *January 23, 1949, Long Beach, California; raised in Jamaica, Wisconsin*   **RESIDENCE:** *City Island, New York*   **EDUCATION:** *three and a half years of college*
**OCCUPATION:** *Photojournalist*   **WHEN OUT:** *1966*

**MARGARET**

**BORN:** *August 8, 1956, New York, New York*   **RESIDENCE:** *City Island, New York*   **EDUCATION:** *B.A., Marketing*   **OCCUPATION:** *Direct-marketing executive*
**WHEN OUT:** *1986*

# Beth Kukucka & Renee Appleby

## FIVE AND A HALF YEARS TOGETHER

*How We Met* ❡ We met in Pittsburgh, Pennsylvania, in May 1989, through a mutual friend.

*Coming Out* ❡ Coming out was challenging, but we are proud of our strength and courage.

*Statement* ❡ RENEE: Beth nurtures my soul. She reflects truth, honesty, goodness, and love that makes me want to be the best that I can be in this world. I love her. ❡ BETH: I feel that Renee is my soulmate, my guide, my most favorite angel on earth. In her I have found a collage of qualities and a combination of everything I have ever loved in anyone.

*How We Spend Our Free Time* ❡ Kayaking, playing sports, photographing, traveling, arguing, and loving.

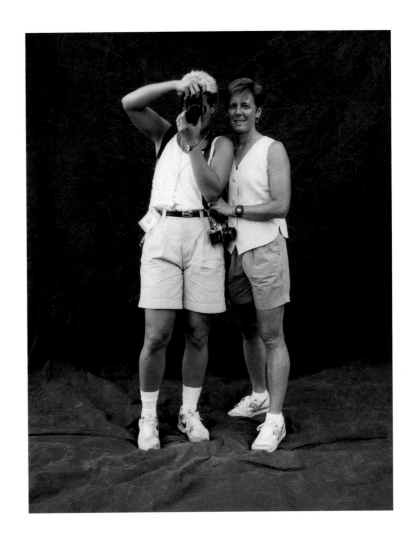

### BETH
**BORN:** *May 20, 1959, Pennsylvania*   **RESIDENCE:** *Venice, California*   **OCCUPATION:** *Photographer*   **WHEN OUT:** *Age five*

### RENEE
**BORN:** *February 23, 1957, Pennsylvania*   **RESIDENCE:** *Venice, California*   **OCCUPATION:** *Registered Nurse*   **WHEN OUT:** *Age twenty-three*

# Stephen B. Gendel & Joseph Trachtenberg

## THREE YEARS TOGETHER

*How We Met* ❡ STEPHEN: We met at the Gay Synagogue in New York. We were introduced by a mutual friend.

*Coming Out* ❡ STEPHEN: I've known my entire life that I was attracted to other males and had a rich sex life in junior high school, but then I suppressed it until my late thirties, which was when I "officially" came out. ❡ JOSEPH: I went to my first gay bar in 1979. I came out to my family within the next couple of years. ❡ STEPHEN: I had been married and have children, so this had a profound effect on my life. But the negatives were short-lived. I would say the biggest impact of coming out has been peace of mind, a sense of personal fulfillment, and a loving relationship with Joseph that is emotionally above and beyond anything I had thought possible. ❡ JOSEPH: It allowed me to become a whole person, and to meet the most wonderful man in the world!

*Statement* ❡ STEPHEN: The most important thing I would want people to know is that we are a couple in every sense of the word. We love and support each other and anyone who says this isn't a family simply doesn't understand what family really means.

*How We Spend Our Free Time* ❡ STEPHEN: What free time? We love to shop and cook, travel and play with our dog, Nikki. Our families also take up a lot of time. When she's not away at school, one of my daughters lives with us, and Joseph has a grandmother who lives in Brooklyn.

### STEPHEN

**BORN:** *May 15, 1945, Hartford, Connecticut*   **RESIDENCE:** *New York, New York*   **EDUCATION:** *Boston University*   **OCCUPATION:** *Television news reporter*

### JOSEPH

**BORN:** *October 9, 1958, Galveston, Texas*   **RESIDENCE:** *New York, New York*   **EDUCATION:** *Austin College and the University of Denver (Graduate school)*   **OCCUPATION:** *Retail (Computer-systems trainer)*

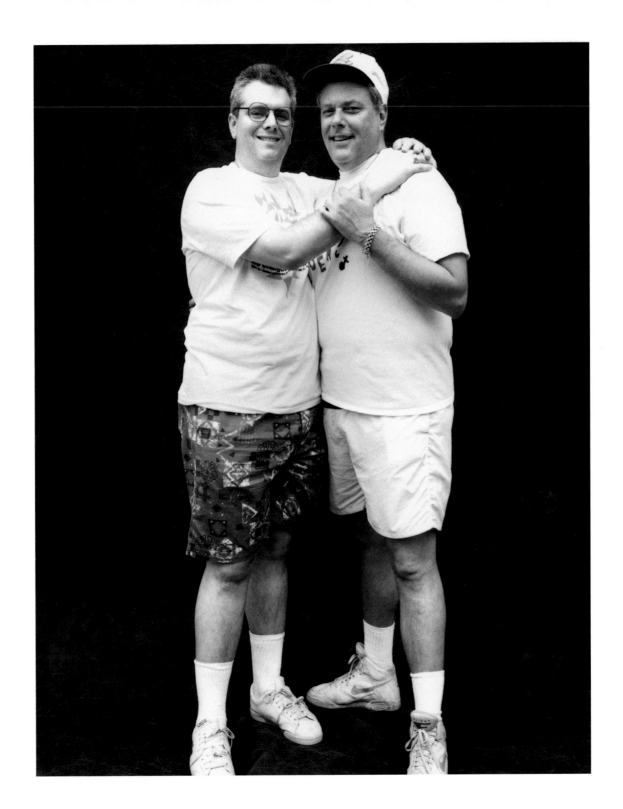

# Ivone Estrada & Ana Hernandez

### TEN YEARS TOGETHER

**Coming Out** ¶ IVONE: I came out in 1965 and became one of the lesbian pioneers to gain awareness for homosexuals in Mexico. ¶ ANA: At the age of nine my mother was aware of my interest in girls. She went to see a psychiatrist. He prepared her for my inevitable homosexuality and she prepared everybody in the family, so I was never in the closet. ¶ I have never had a problem with my homosexuality and I never feel any discrimination in any place or with anybody in Mexico. Maybe that's why I never enjoy any club or group of lesbians, because they always fight exclusively for lesbians' rights, and I want to fight for all human rights.

**Statement** ¶ IVONE: I was born in northern Mexico where people are more macho than elsewhere. Pedro Infante, Mexico's most famous movie star, and Julio Cesar Chavez, the boxer, are from there. I would go to the nightclubs with my gang, the Canallas, and freak out all the heterosexuals. At that time there were no places for gays in Mexico ¶ ANA: At the age of eighteen I met my first girlfriend and found my first job as a reporter in a radio station. After the first month I told them that I was gay, but because I was doing a very good job, they didn't care. In 1980 I was the first voice in radio to speak out against the police and gang violence against the homosexual community in Mexico City. ¶ Seven years ago we converted to Islam. Everybody in our mosque knows about us. We moved to New York two years ago to follow our spiritual guide who lives here. ¶ We have a Scottish Terrier.

**IVONE**

**BORN:** *1943, Sinaloa, Mexico*   **EDUCATION:** *Psychology, University of Mexico*   **WHEN OUT:** *Age twenty-two*

**ANA**

**BORN:** *July 18, 1961, Mexico City*

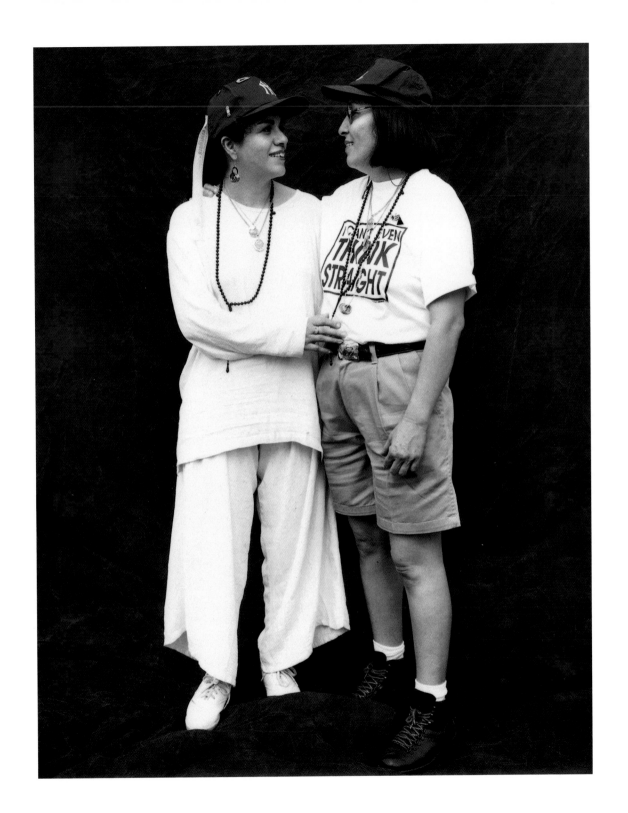

# Philip T. McCabe & David B. Stevens

## THREE YEARS TOGETHER

*How We Met* ❡ DAVID: We met at a pool party held by a social club. A mutual friend introduced us. This relationship has been the hardest one I've ever been in, yet it is also the most comfortable I've ever had. It has taken me thirty-six years to grow up and to find the man that I plan to spend the rest of my life with. It is a special honor to share him with the rest of the world in this book. ❡ PHILIP: Two weeks after Dave moved in, the great northeaster of '92 hit the Jersey shore. We went three days without heat or electricity. Parts of our town were destroyed by the storm. If we could survive that, I knew we could see it through the rough times.

*Coming Out* ❡ PHILIP: I was married for three years and not very happy. Coming out was a freedom, a true liberation. It's been an exciting journey. Now I'm out personally and professionally. ❡ DAVID: When I came out my immediate family disowned me. I lost one "friend" but other than that, being out has been very positive.

*Statement* ❡ PHILIP: Professionally, one of the things I like best is helping others to come out. Watching them go through the transition and being proud of who they are is a wonderful gift of my work.

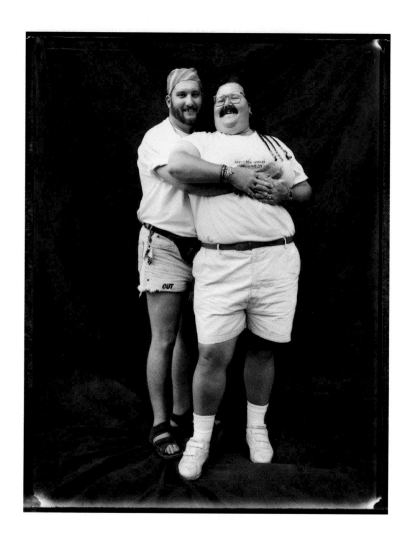

### PHILIP

**BORN:** *October 13, 1956, Red Bank, New Jersey*   **RESIDENCE:** *Ocean Grove, New Jersey*   **EDUCATION:** *Therapist / Mental Health Program*
**OCCUPATION:** *Certified compulsive-gambling counselor, creative-arts therapist*   **WHEN OUT:** *1978, age twenty-one*

### DAVID

**BORN:** *May 24, 1957, Bucks County, Pennsylvania*   **RESIDENCE:** *Ocean Grove, New Jersey*   **EDUCATION:** *High school*   **OCCUPATION:** *Retail manager / graphic artist*
**WHEN OUT:** *Age nineteen*

# Alejandro Batres & Wade Martin

## ONE YEAR AND TWO MONTHS TOGETHER

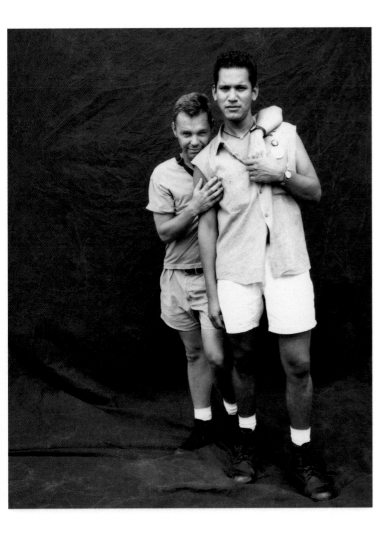

*How We Met* ¶ In a club, through a mutual friend.

*Coming Out* ¶ WADE: Overall very positive.

*Statement* ¶ We are constantly bridging the gap between our differences. We didn't choose our culture, sexual preference, or generational realities. We simply are who we are, and we try to be true to ourselves and to each other. ¶ We rediscover each other's vulnerabilities and take the challenge to understand. It's often rewarding and sometimes painful. We face each day and ride the roller coaster of love, and hopefully grow. ¶ Latino with southerner; postmodern with modern; Madonna with Donna Summer; mangos with magnolias; Ricky with Lucy . . . babalu, babalu. ¶ We reflect the contrasts and similarities of ourselves out to the world and into our hearts. Love remains the key.

*How We Spend Our Free Time* ¶ ALEJANDRO: Friends, music, and heated conversations about ourselves and our purpose in life. WADE: Painting and getting together with friends.

### ALEJANDRO
**BORN:** *August 10, 1966, Managua, Nicaragua*  **RESIDENCE:** *Washington, D.C.*  **EDUCATION:** *Secondary education (Spanish Literature)*
**OCCUPATION:** *Writer*  **WHEN OUT:** *1987*

### WADE
**BORN:** *February 4, 1958, Birmingham, Alabama*  **RESIDENCE:** *Washington, D.C.*  **EDUCATION:** *B.A., Management/Art History*
**OCCUPATION:** *Marketing manager, publishing/artist*  **WHEN OUT:** *July 4, 1977*

# Ned Kemeys & Bob Prewitt

## EIGHT AND A HALF YEARS TOGETHER

***How We Met*** ❡ NED: It was February 1986. I had been single for a year after ending an eight-year relationship. I convinced my best friend to go on the inaugural trip of the first all-gay cruise liner "RSVP." I spotted Bob the first day during the send-off and was drawn to him and his lavender high-top tennis shoes. I have videos of that first sighting, starting with those shoes and panning up to him and his friend talking about me. It seems he was taken with my all-black attire and what, he swears, is an uncanny resemblance to Sam Elliott (I don't see it). We ran into each other in the first port, Key West, but we didn't connect. ❡ We eventually met and even tricked a couple days later. But I loved being single and had no desire to settle down. Then WHAM! Our paths crossed again the next night. I had had a harrowing day having survived the crash of our sight-seeing bus, which had rolled over into a swamp. Bob helped soothe my rattled nerves, and I helped get him through a blue mood. We were inseparable for the rest of the cruise. And after two months of traveling back and forth to Denver, I moved there. We've been together ever since. ❡ BOB: When Ned and I first met and fell in love on the first "RSVP" gay cruise in 1986, it was so romantic and idyllic. I had never felt such powerful, positive feelings for anyone before. There were tears, and much laughter and silliness. (We joked with our cruise mates that we had discovered we had at least two major things in common: country music and cross-dressing!) We found that we both loved Hal-

loween and masquerade parties and sometimes delighted in outlandish drag just to liven things up and to make people laugh.

***Coming out*** ❡ BOB: It released a lot of stress, anxiety and self-loathing, and made it possible to relax around my family a lot more. Yet coming out to strangers and acquaintances can still be anxiety producing. ❡ NED: It turned out to have had no real effect on any facet of my life. Both my parents said they always knew and my friends were very cool, but it was 1974 in Washington, D.C., and being gay or bisexual—or at the very least having a gay friend— was very cool.

***Statement*** ❡ BOB: The relationship's turned out be a lot of work—as I guess they all are. In a lot of ways Ned and I are such opposite personalities: I'm left-brained, he's right-brained; he's mechanically inclined, I'm good at detail analysis and trouble-shooting logistics; I'm anal-retentive and he's, well, anal-explosive (so to speak); I like to talk things out, he prefers to retreat and implode. All this is nice in some ways, but it also makes it that much harder. I've had to learn to be a lot more patient these last eight years—I'm sure he'd say the same thing. ❡ But the rewards of that patience have been many. We have had crazy, silly, creative times together, some wonderful trips, tons of laughter, unending companionship, and irreplaceable support as we've weathered the

storm of AIDS and watched it take so many friends. Speaking of AIDS, Ned and I finally bit the proverbial bullet and got ourselves tested in 1988. Both results came back positive. A year later I found my first KS lesion. We've been dealing with my KS for five years now—it's basically been my only health challenge, but it's been plenty, thank you very much—especially this past year as it's gotten a lot more aggressive. The emotional aspect of coping with a visual symptom has been the worst part—your eyes constantly remind you of what you're dealing with, as do the eyes of others. I think all in all, I've been pretty brave about it. And while I'm being realistic, I haven't gotten depressed all that often. I'm still hopeful, still seeking and trying new treatments. What else can you do? ❡ Ned's T-cells have declined over the years, but clinically he's as healthy as a horse. (Apparently he belongs in one of those curiously healthy HIV subgroups.) He's been great support through my health crisis, a rock of strength who hasn't allowed me to indulge in self-pity when the impulse strikes. Yet the strain of watching the KS slowly take me over these last few years has inevitably taken its toll on him. His moods have become very volatile, and I sense a growing emotional distance from me. I hope we can continue to huddle against the storm together, as we envisioned during our first days together, but I can't predict what's going to happen with us. That seems to be one of the nastier realities of AIDS—it often diabolically manages to divide

### NED

**BORN:** *October 4, 1951, Tacoma Park, Maryland*     **RESIDENCE:** *San Diego, California*     **EDUCATION:** *High school graduate*     **OCCUPATION:** *Retired due to disability*
**WHEN OUT:** *June 1974*

### BOB

**BORN:** *April 6, 1958, Abilene, Texas*     **RESIDENCE:** *San Diego, California*     **EDUCATION:** *B.A., Journalism, University of Texas at Austin (1980)*
**OCCUPATION:** *Customer-service agent (retired, AIDS disability)*     **WHEN OUT:** *To self and sister 1976, to mother 1979, to father 1987*

couples before it moves in to conquer. For now, we continue to huddle together.

***How We Spend Our Free Time*** ¶ BOB: Going to a lot of movies, reading (especially magazines), working out, playing chess, playing with our three cats ... going to doctors and chiropractors and acupuncturists and massage therapists. I spend a lot of time doing things to try to stabilize or improve my health—including staying well-informed. ¶ NED: Since we've retired it's all free time, so we bought an RV and have decided to see all of the United States. So far in the past year we have been to thirty-five states and logged 28,000 miles and hope to complete them all in the coming year. We are also big movie buffs and love to country dance.

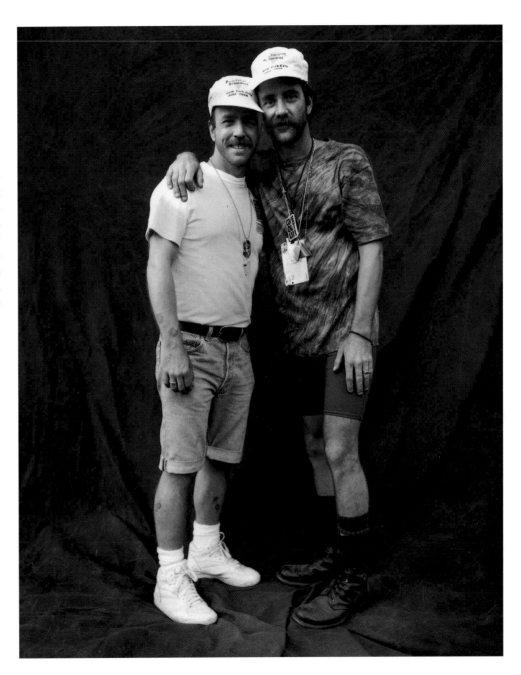

# Albert Acosta & Phillip Green

## THREE YEARS TOGETHER

***How We Met*** ¶ PHILLIP: We met in a bar in the Village, Boots and Saddle, on Christopher Street. I was on my way home and stopped in. He made eye signals until I approached; we're both very shy. We talked for about three hours and the rest is history.

***Coming Out*** ¶ ALBERT: I never really came out officially to my family, although my brother is also gay. We were raised Catholic and learned not to talk about things, hoping they would go away. They didn't. I was in preseminary and saw the Catholic Church from the inside. I saw that it really wasn't about religion at all, but about politics and control of people. Realizing that made it easier to accept my homosexuality. I guess my religion helped me to accept myself, seeing the bigotry of the Church. ¶ PHILLIP: I came out when I was twenty, when I met my first lover. Up until that time I kept pushing my homosexuality to the back of my mind and thinking it would someday pass. I was really in denial and I kept myself practically unaware of it. Having my love returned taught me to love myself, although it was a long process. Coming out was a major milestone. I didn't realize how low my self-image was before I fell in love. It was like having a great burden lifted. Then I had the time and attention to give to those other parts of my life that needed healing. I was sure the family already knew, so I was surprised when they were so shocked. They knew I was "different," but didn't think I was gay. My mother is great. She

has become an advocate. I'm very lucky to have her as a mother. She has provided me with a lot of support. She's always there when I need her. I have four siblings, with a twenty-year difference between the oldest and myself. My older sister did suspect and she is okay with it. She's always been great. My older brother seems okay with it, although I've never really talked with him about it. The other two have negative feelings. It threatens them somehow, or they just choose to live in a fantasy world where homosexuals don't exist. My father died when I was thirteen. I believe he knew and would have accepted me. He was very wise and understanding of life and human nature in general. I know he would have accepted me and would still love me. It used to really hurt me that my family didn't fully accept me. It was very important to me at one time. I don't make it a big part of my life anymore to care what people think or to try to convince them to accept homosexuality as "normal." I really did crave their acceptance at one time but now all that energy gets channeled into political stuff and the education of people one at a time. I think if we are going to change society it's going to be person by person and from the inside out. It's already changing. Homosexuality is already part of the mainstream, and I'm glad to be a part of it. I'm really lucky in the friend department. They're all still with me. I didn't lose anyone for coming out.

***How We Spend Our Free Time*** ¶ ALBERT: I read,

go to the gym. We go exploring different parts of the city. I enjoy movies. We enjoy our home a lot and often just stay in and watch TV or read, especially when it's cold out. ¶ PHILLIP: There's a lot to do in New York. We both love the city and spend a lot of time doing city things. We often just walk around for hours. We go to museums and parks. We're going to get rollerblades and bikes someday, when we have an apartment big enough to hang them in.

---

### ALBERT

**BORN:** *February 26, 1961, Hartford, Connecticut*   **RESIDENCE:** *New York, New York*   **EDUCATION:** *Some college, technical training*   **OCCUPATION:** *Nursing assistant*

### PHILLIP

**BORN:** *August 29, 1960, Los Angeles, California*   **RESIDENCE:** *New York, New York*   **EDUCATION:** *Currently working on B.A.*
**OCCUPATION:** *American Sign Language interpreter*

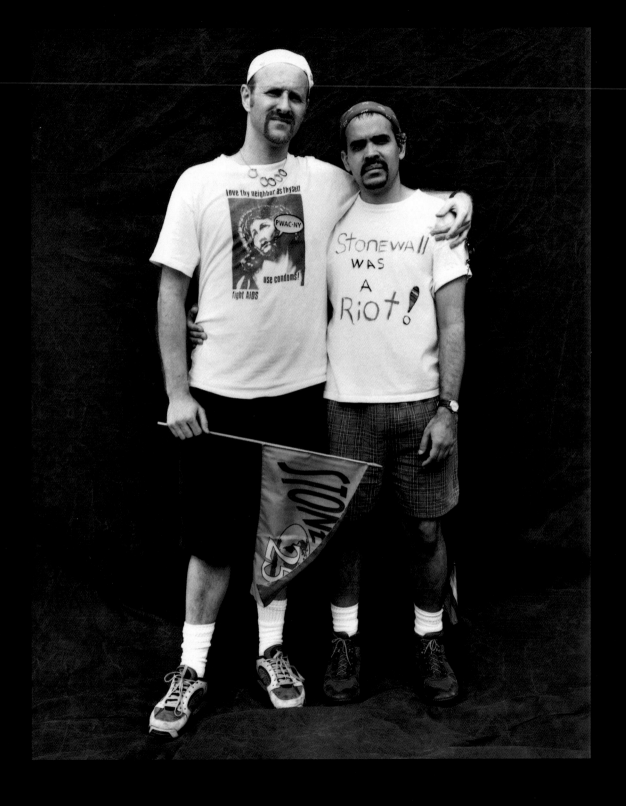

# Michael Dillard & Edward J. White

## NINE YEARS TOGETHER

***How We Met*** ❡ MICHAEL: I met Eddie when he came into the restaurant where I worked. He quickly became a Friday-night regular, and although I thought he might be interested in me, nothing was said until six months later when he asked me out. ❡ EDWARD: One night in 1986 I went to try this new restaurant in my old neighborhood. The hostess seated me and my friend and said our waiter would be right with us. A moment later we were handed menus and then asked in a charming Southern drawl if would we like something from the bar. Well! I was like melting ice, and wondered if Mike was on the bar menu. For the next six months, I went to the restaurant and always sat in Mike's section. During this time while we were getting acquainted, neither one of us was sure if the other was gay. On November 22, 1986, Mike and I had our first date and all of our questions were answered. ❡ MICHAEL: I think it was his sense of humor that first caught my attention—well, after his gorgeous blue eyes, that is. That was nine years ago and Eddie is my best friend as well my lover.

***Coming Out*** ❡ MICHAEL: After coming out as a junior in college I felt more comfortable and relaxed with my friends. In fact, if you can't be yourself then you're depriving others of the opportunity to know you. They end up knowing only the person you pretend to be. ❡ EDWARD: Being somewhat of a private person, I never felt it was anybody's business whether I was gay or not. I did, however, tell my best friend in 1987. Unfortunately, that friend thinks I'm just going through a phase. Six years later I told my sister and she said she knew. I replied, "Why didn't you tell me?!" As far as the rest of my family goes, they weren't born under rocks. Coming out has affected my life in a positive way. I am much happier with myself; my life with Mike is like a story book and I'm in a permanent happy ending.

***How We Spend Our Free Time*** ❡ Going to the theater, taking vacations, and going to street fairs.

### MICHAEL
**BORN:** *July 28, 1957, Tuscaloosa, Alabama* **RESIDENCE:** *Fort Lee, New Jersey* **EDUCATION:** *B.F.A., Speech/Theatre* **OCCUPATION:** *Waiter*

### EDWARD
**BORN:** *February 24, 1951, New York, New York* **RESIDENCE:** *Fort Lee, New Jersey* **EDUCATION:** *High school, some college*
**OCCUPATION:** *Supervisor for a cleaning company*

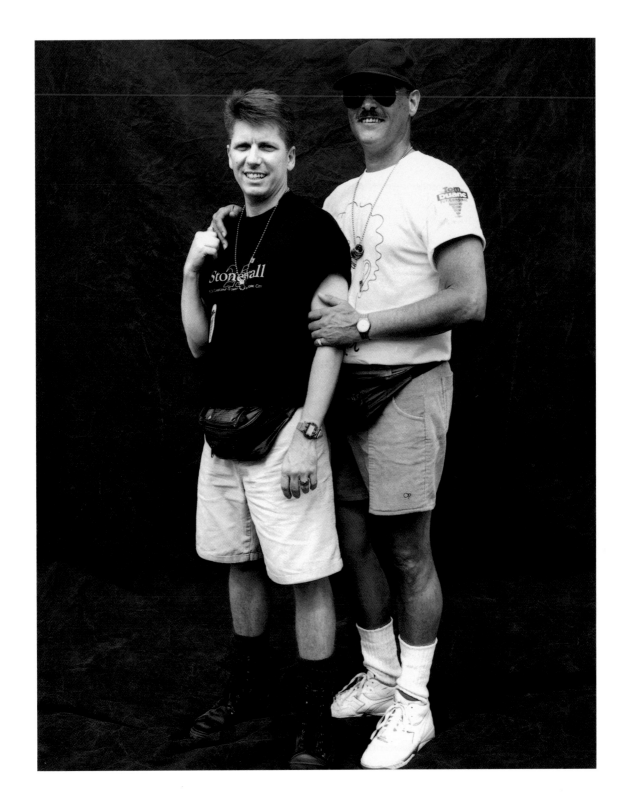

# Chris Knickerbocker & Kim Lauren Trahan

## ONE YEAR TOGETHER

***How We Met*** ❡ CHRIS: We were "friends of friends." Things clicked for us when I was invited to her house by mutual friends. It was to be a bon voyage brunch—Kim was leaving the house she and her exlover shared. As soon as I walked into her house I felt at home. We had the same magazines and the same style in decorating (we both love old houses and antiques). I immediately knew something could happen. I wanted it to happen and I knew that if it did it would be very serious. It was a really physical, spiritual reaction, and my heart felt heavy. I spent the next few weeks wondering how I was going to get something going. We were once again invited to a get-together by friends. By the end of the evening we flirted our way into a passionate kiss. We talked for hours. ❡ My attraction for Kim was very emotional at first, which was quite different for me. We now have an incredible, intense, wonderful physical and emotional relationship. ❡ KIM: I had been involved in a ten-year relationship that was ending. On the day I moved out of my home two friends and their neighbor came to give me a bon voyage party complete with fresh fruit and champagne. After an hour of laughter on my front porch, I was hopelessly and happily smitten with the neighbor—sweet red-haired Chrissie! Even though my life was changing dramatically, I couldn't resist her. Too many days later, we finally kissed and kissed and kissed.

***Coming Out*** ❡ CHRIS: My family knew without me telling them, as did my oldest friends. One said, "Of course I knew, I love you, how could I not know." ❡ Most of my sorority was gay but those who weren't were homophobic and had a hard time. I was a cheerleader and they couldn't get how I could be a cheerleader and a lesbian too! ❡ KIM: Family responses varied initially, but I consider myself lucky and blessed by their support now. Friends? Suddenly there were many more! And the "quality" of friendship—the love, trust, and fun—was different than ever before. Job? I was one of four lesbians in my department, so . . .

### CHRIS

**BORN:** *May 7, 1959, Medina, New York*　**RESIDENCE:** *Owego, New York*　**EDUCATION:** *B.S.W., Lock Haven University, M.Ed., Cambridge College*
**OCCUPATION:** *Director, Student Financial Aid & Employment*　**WHEN OUT:** *1979*

### KIM

**BORN:** *August 30, 1958, Exeter, New Hampshire*　**RESIDENCE:** *Owego, New York*　**EDUCATION:** *B.S., Athletic Training*　**OCCUPATION:** *Athletic trainer, coordinator of sports medicine*　**WHEN OUT:** *1982*

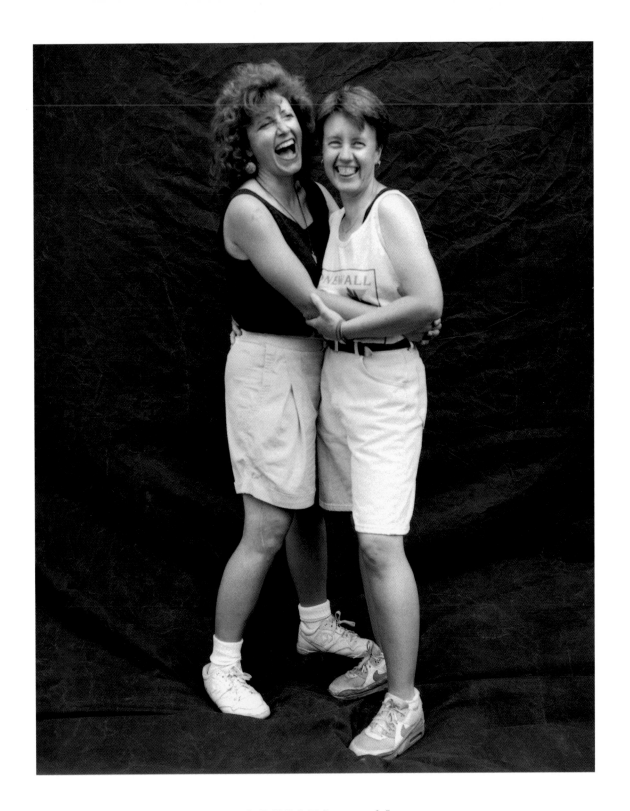

# Ron Schultz & Randy Wiley

## THREE YEARS TOGETHER

***How We Met*** ¶ We were introduced by a friend at a local club.

***Coming Out*** ¶ RON: When I came out it wasn't much of a big deal to anyone. Everyone was very supportive. As for myself, I felt a lot better and at ease. ¶ RANDY: I think the hardest thing about being a gay couple is not being able to show affection in public. (I would, but Ron won't.) I get very jealous of my straight friends. They can hold hands in public without fear. That would mean a lot to me. They don't know how lucky they are.

***Statement*** ¶ RANDY: Ron and I have been going out for three years. We've been living together for two. Ron was nineteen when I met him and I was twenty-five. No one thought we would last a month because of our age difference. ¶ For two people who have almost nothing in common we get along pretty well. I love science fiction, going to the movies, and the outdoors. Ron, well, he hates all of that. I guess that's why we've become such homebodies. Most nights we just stay home and watch TV or play Sega. ¶ I just recently told my family that I'm gay. They took it very well. Now I hope they'll accept Ron as part of the family. We'll see. ¶ For the future, we plan to move to Florida so Ron can be with his family (for a while at least). While there, I think we would both like to further our educations.

¶ We're not perfect. We have our problems, but we both love each other very much.

***How We Spend Our Free Time*** ¶ RON: Me, I don't like to do much but spend time at home. Once in a while I'll go to a club with Randy or my friends, or I will go shopping in the city.

## RON

BORN: *August 11, 1972, Middletown, New York*   RESIDENCE: *Newton, New Jersey*   EDUCATION: *High school*   OCCUPATION: *Factory worker*   WHEN OUT: *1991*

## RANDY

BORN: *March 18, 1966, Newton, New Jersey*   RESIDENCE: *Newton, New Jersey*   EDUCATION: *High school*   OCCUPATION: *Sporting-goods sales*   WHEN OUT: *1989*

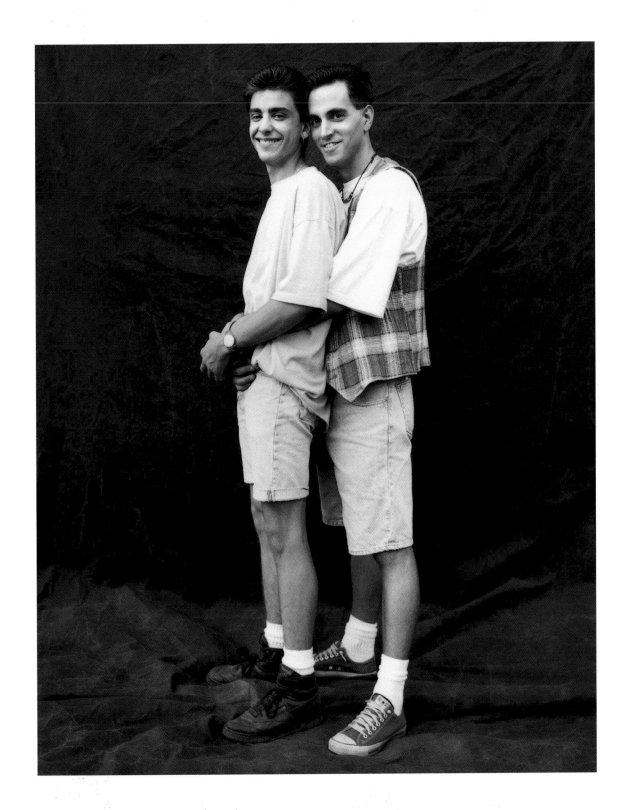

# Ann Marie Mills & Elizabeth Rowland

## TWO YEARS AND FOUR MONTHS TOGETHER

***How We Met*** ❡ We met three years ago in church. I asked Ann Marie if she would go with me on a church-sponsored charity walkathon. She did, and we talked the entire five miles. ❡ After spending many months just talking and getting to know each other, we finally connected.

***Statement*** ❡ ANN MARIE: My lover and I have had a long two and half years together. We are trying to sell both of our homes so we can live together. We want to be together so badly but neither house can accommodate two adults, three dogs, three cats, and allow us to be close enough to work. We hope the real-estate market breaks soon. ❡ After Elizabeth's mother died unexpectedly this February, I realized that nothing is as important as sharing my life with her. I don't want to wake up one morning and realize that our time together is gone and that we never got to spend it together because of "outside forces." Time is precious. Don't let it fly by without purpose. We've talked about starting a family (i.e., children) but we need to live together first to see if it is a realistic goal for us. I pray that we will be given all we need. ❡ ELIZABETH: Connecting with my partner, Ann Marie, has been one of the most beautiful experiences in my life. She's warm, sensitive, insightful, sexy, intelligent, centered, and just fun to be with. I'm looking forward to many long years with her.

***Coming Out*** ❡ ANN MARIE: Being in a relationship did not mean I was a lesbian. I came out sexually with my best friend but emotionally I came out to myself at an Alix Dobkins concert. I wrote Alix a card and she sent a congratulatory note back to me. ❡ Emotionally it was like coming home. I was so at peace with myself and the woman I was with. It brought me closer to some family members and yet I feel removed from others. ❡ It brought me closer to a sense of spirituality versus a patriarchal church. I knew there must be a God to have given me such a wonderful life with a woman. ❡ ELIZABETH: Coming out made me feel as if the fragmented pieces of my life were finally fitting together. It was wonderful.

***How We Spend Our Free Time*** ❡ ELIZABETH: Depending on the season, I enjoy biking, hiking, cross-country skiing, kayaking, reading, spending time on P'town beaches, developing my skills as a silversmith, and spending time with the dogs. We also love traveling together. ❡ ANN MARIE: Renovating houses, traveling on mini vacations, taking the dogs for walks. What we'd like to do: stay on the beach in P'town, climb the rocks in Arizona.

**ANN MARIE**

BORN: *January 17, 1964, Glens Falls, New York*   RESIDENCE: *Oneonta, New York*   EDUCATION: *M.A.*   OCCUPATION: *Social worker*   WHEN OUT: *1985*

**ELIZABETH**

BORN: *July 11, 1951, Brooklyn, New York*   RESIDENCE: *Burlington Flats, New York*   EDUCATION: *Currently in college part-time*
OCCUPATION: *Shipping/receiving/warehousing supervisor*   WHEN OUT: *1969*

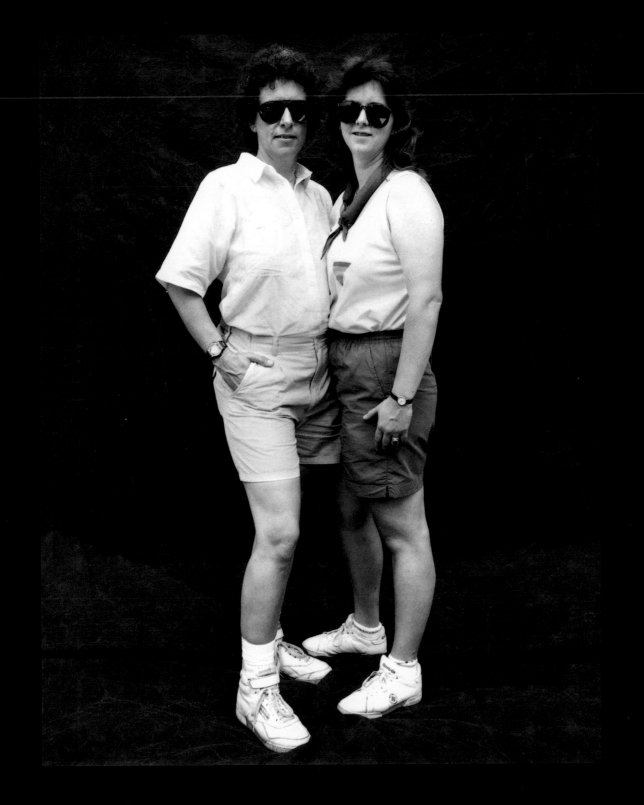

# Scott Harrington & Jorge Gonzalez

## THE WEEKEND TOGETHER

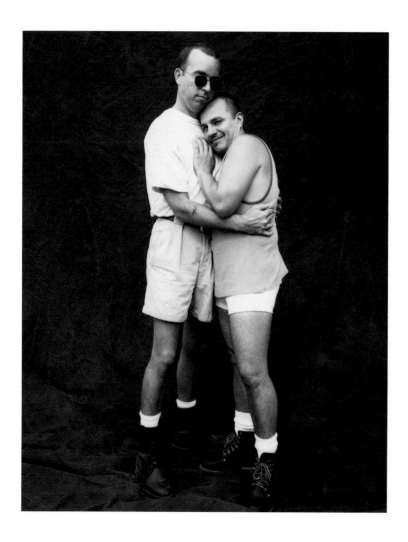

*How We Met* ❡ JORGE: This same weekend at a friend's house.

*Coming Out* ❡ Being Puerto Rican and gay is difficult for me, my family, etc. For me drugs were the easy way out. Currently I am very happy and healthy, living with HIV. I'm living a wonderful life and have been drug-free for several years. I hope gay men wake up and stop abusing their bodies and minds. I feel they will live longer. I also hope they find love and happiness. I did.

*Free Time* ❡ Working and admiring how wonderful it is to be alive.

### JORGE

**BORN:** *December 24, 1957, Bronx, New York* **RESIDENCE:** *Queens, New York* **EDUCATION:** *High School* **OCCUPATION:** *Hairdresser* **WHEN OUT:** *1970s*

# Ken Martin & Curtis Winkle

## EIGHT YEARS TOGETHER

**Coming Out** ❡ KEN: Coming out transformed my outlook on life by forcing me to identify who I am and what I want in this very brief life.

**Statement** ❡ KEN: I think Curt is still sexy after all these years.

**How We Spend Our Free Time** ❡ CURTIS: Bicycle touring, gardening, and rehabing house. ❡ KEN: Junk collecting with a passion, home renovation and construction projects, swimming, triathlons, traveling and sewing.

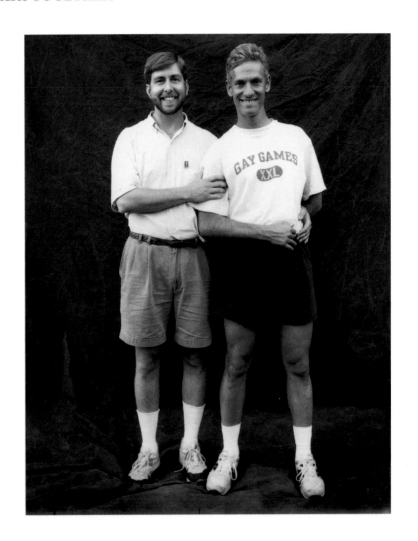

### KEN
**BORN:** *September 23, 1958, Hoboken, New Jersey* **RESIDENCE:** *Chicago, Illinois* **EDUCATION:** *B.A., English, New York University, 1981* **OCCUPATION:** *Marketing manager* **WHEN OUT:** *Around 1985, shortly after moving from NYC to Chicago*

### CURTIS
**BORN:** *May 22, 1957, Pierre, South Dakota* **RESIDENCE:** *Chicago, Illinois* **EDUCATION:** *B.S., Indiana State University, 1978; M.C.R.P., Rutgers University, 1980; Ph.D., Urban Planning and Policy, Rutgers University, 1986* **OCCUPATION:** *Associate professor* **WHEN OUT:** *1978*

# Jonathan Wilson & Laurie Lynd

## ONE AND A HALF YEARS TOGETHER

*How We Met* ❡ Through a mutual friend.

*Coming Out* ❡ LAURIE: When I was 19 I came out to my parents. I'd known I was gay since I was 16 but at 19, I had a boyfriend, Micah, who I was madly in love with and who gave me the momentum to come out. I was fortunate in that I had three close male friends in high school, all of whom I'd known since grade 7. We all realized we were gay at pretty much the same time. So, I was in the unique position of being gay in high school and having support from close friends—and therefore felt relatively "normal"—unusual for the 1970s. We weren't out to others, only to ourselves. My parents were okay, though my mom was quite upset initially. They now are tremendously supportive, even to the point where my mom will comment if someone makes a homophobic remark. I have a great relationship with them both. I think coming out is a life-long process, with various stages. I am 36 now and still recognize hurdles I have to overcome in terms of my own internalized homophobia. I think it is hard not to be scarred in some ways by growing up in a homophobic world. I hope in generations to come this journey will become easier. As the song goes, however, I am glad to be gay, and despite the difficulties this occasionally presents, I have always felt this way. I value the perspective being gay has given me, and find much of what I have to say as a filmmaker comes from this point of view.

*Statement* ❡ I have been out to all of my family and friends more or less since my early twenties and have long had no interest in anyone with whom I could not be out. I am fortunate to work in a business where my being gay is not unusual. Initially, however, when at film school, I was surprised at how straight it was, unlike the theatre world which is much more mixed. The films I have been making have mostly been gay-themed, and so my peers have mostly assumed, correctly, that I am gay. ❡ I have never been religious, though always very interested in religion. Coming out had no impact on that part of my life.

*Addendum* ❡ Jonathan and I were together for two and half years and this photo was taken during that time. He's the best relationship I've had yet—where we were best friends as well as lovers. I'm sorry we didn't make it in the long run, but as Rhoda Morgenstern would say: "At least this time I'm breaking up with a better class of guy." ❡ I just completed my first feature, to be released in Canada in 1996. Jonathan acts in this film. We were a couple when we made it, and we really enjoyed working together.

### JONATHAN

BORN: *July 25, 1963, Canada*   RESIDENCE: *Toronto, Ontario, Canada*   EDUCATION: *College*   OCCUPATION: *Actor*

### LAURIE

BORN: *May 19, 1959, Toronto, Ontario, Canada*   RESIDENCE: *Toronto, Ontario, Canada*   EDUCATION: *B.A., M.F.A., Filmmaking*   OCCUPATION: *Filmmaker*
WHEN OUT: *Age nineteen*

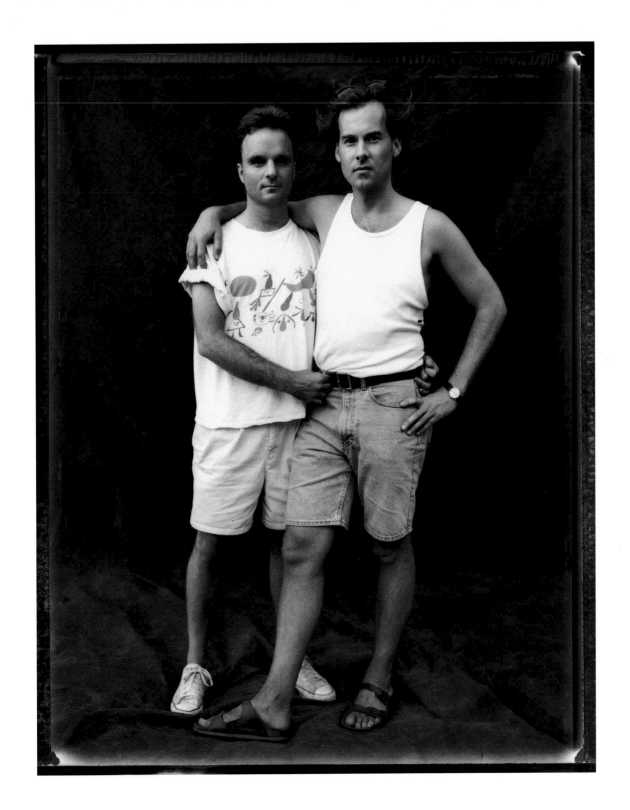

# J. Peter Castro & J. Derek Demaree

## FIVE AND A HALF YEARS TOGETHER

*How We Met* ¶ In the summer of 1989, Pete was at the University of Michigan for a prefreshman orientation, living in the dorms for a month. Derek was in grad school, just beginning the big push to finish his dissertation research. We met on campus, just cruising people on the central campus diagonal. Like most relationships we know, lust led to friendship, and friendship to love! We didn't know it, but we met on the twentieth anniversary of the Stonewall riots. Since New York Pride is scheduled to coincide with that date, we try to get to it each year as an anniversary celebration. It's a great chance for us to get out and explore different sides of gay culture and to really celebrate the good luck that we've had in being gay and finding happiness.

*Coming Out* ¶ PETER: I was losing interest in religion prior to coming out, but coming out really severed the ties with my Catholic upbringing. I started to come out by telling my high-school friends one at a time. Their reactions varied from complete acceptance to complete denial. ¶ DEREK: I was very active in the fundamentalist church I grew up in, and coming out really put a wall between me and that past. I had to cut off most contact with my old friends in order to pursue a life that would make me happy. My family is still devastated, and even simple phone calls home are often painful, although they haven't completely cut me off. I've never had any negative reactions at work, even though I work for a conservative and notoriously homophobic employer (the U.S. Army!). In engineering, you are often judged strictly on your ability to do the job. I think I'm respected as much as any God-fearing straight person in the place.

*Statement* ¶ I suppose the key point to understand about us is that we came out together, despite our age difference. Pete is more typical of so many gay youths recently and was aware of his orientation very early and never really had any internal conflicts about it. Derek, on the other hand, had to dig through years of religious training and repressed sexuality before he was ready to face it. We didn't have any other gay friends for the first year we were together; we "discovered" how our relationship could be with very little outside influence. Because of this, our rules and roles sometimes don't match either the traditional hetero family structure or the proper social roles found in the somewhat conservative Boston gay community. We pretty much live like we want to, with gay friends and straight friends, sometimes going to bars and being part of the "gay community" and sometimes not frequenting them for months. Although we've been together for over five years, this is the first year we've lived together, so we've felt more like a couple recently—with furniture and holiday ornaments and kitchen stuff—and we're planning on a long future together. Once you've gone through all the ups and downs of coming out together, you know that you'll be able to survive anything if you've got someone you love and respect at your side.

*How We Spend Our Free Time* ¶ Both of us work with Boston's gay and lesbian chorus, Coro Allegro; Pete as paid staff (production manager) and Derek as a singer and sometimes board member. We also love to travel around New England—long drives through the countryside, trips to Cape Cod, the north shore of Massachusetts—and elsewhere. We just got back from our first trip to Europe with a classical chorus from Cambridge, Massachusetts. We sang concerts in Germany and Switzerland, then rented a car with friends and drove through Eastern Europe. Everyday activities include jogging and walking around Boston, staying in shape, and undoing all that hard work by cooking! Derek will be transferring to Maryland next year, so we are trying to enjoy as much of the fantastic cultural life of Boston as possible in what is probably our last year here.

### PETE

BORN: *March 9, 1971, Detroit, Michigan* RESIDENCE: *Boston, Massachusetts* EDUCATION: *Undergraduate work at the University of Michigan, would now like to work toward a master's degree in social work* OCCUPATION: *Temp work, part-time student* WHEN OUT: *Age fifteen*

### DEREK

BORN: *January 1, 1964, Lexington, Kentucky* RESIDENCE: *Boston, Massachusetts* EDUCATION: *B.S., Texas A&M University, Ph.D., University of Michigan, Nuclear engineering* OCCUPATION: *Materials-science research engineer for the U.S. Army Research Laboratory* WHEN OUT: *Age twenty-five*

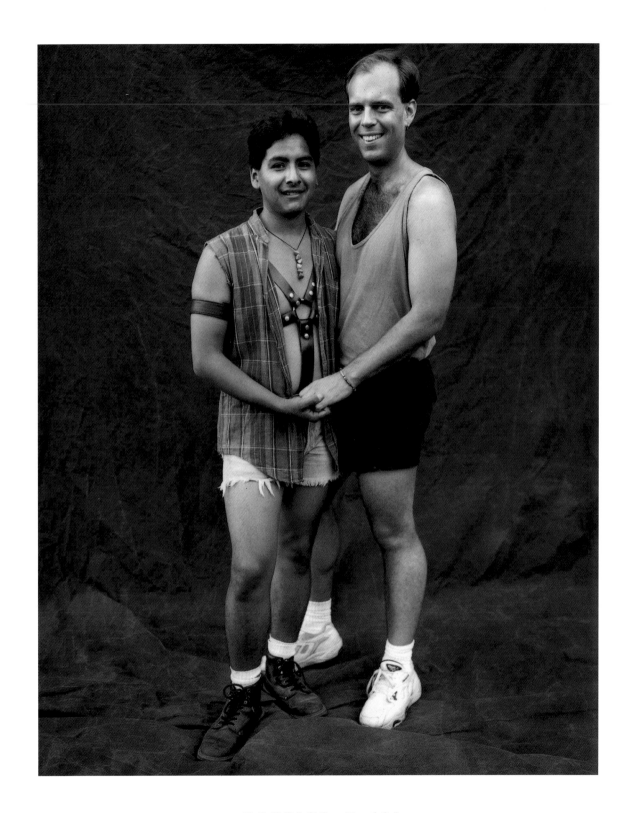

# Rita Remick & Pam Vlerebome

## ONE AND A HALF YEARS TOGETHER

***How We Met*** ¶ RITA: Pam and I began as pen pals and met in person at a Friendly's Restaurant. Pam was in the process of coming out. We became fast friends, then lovers.

***Coming Out*** ¶ RITA: Coming out made me feel complete, a total person. It allowed me to feel truly loved for who I am. This was very empowering for me and enabled me to eliminate confusing feelings that had been suppressed for many years. ¶ My parents, two sisters, and two brothers continued to give me their unconditional love and support. My sister would drive with me to meetings when I was coming out and later let me stay at her apartment when I left my husband. ¶ My exhusband was very homophobic and succeeded in alienating my children from me for several years as they were young and impressionable. I joined a gay mothers group which helped me cope with the extremely difficult situation of having custody of my youngest child, then only five years old while my ex had custody of my three daughters. Now my children live with me and our relationship is good again. All are supportive and accepting and have marched at two gay-rights marches. My eighty-two-year-old mom also attended. I'm very lucky. ¶ I lost a family of straight friends and their children. I had known them for twenty years. Since then I have gained many gay friends whom I hold dear. Some straight friends—most—are accepting. ¶ I am out at work to some close peers, but mostly I am closeted for fear of repercussions. I am closeted to my patients as most are elderly and I feel it would be counterproductive. ¶ I have a deep inner faith and strong moral convictions. I was raised Roman Catholic with fifteen years of Catholic schooling, but I have difficulty embracing that religion now. When possible, my partner and I attend an accepting Episcopal church. Pam and I pray at meals and at night. ¶ PAM: Coming out allowed me to be who I really am. I was finally open to let myself love a woman. My family is not dealing at all well with my change in life. My two siblings have still not met my partner. My parents are trying, but do not fully accept it. My son, who is high-school age, is wonderful. He still lives with my exhusband but visits Rita and me every other weekend and is becoming more aware and accepting of me as a lesbian. There are a few of my straight friends who accept me, but most of my friends are new friends who are also lesbian. I am not out at work. I wish I could be, but I am afraid of losing my job. I have always held my faith to be a strong influence in my life. I am hoping to find a church nearby that is accepting to gays and lesbians.

***Statement*** ¶ RITA: I feel very proud and lucky to be who I am. I am deeply in love with Pam, a very special woman, and someday we hope to marry when it's legal. We are very blessed. ¶ PAM: My life is full of love and I look forward to my life with my partner, Rita. I hope that someday my family will accept us as a couple—then my life will be in full harmony.

***How We Spend Our Free Time*** ¶ PAM: We enjoy summer sports; boating, and swimming. Rita water-skis and I drive the boat. I am teaching Rita how to play golf, sledding in the snow, camping, traveling, watching movies, postcard collecting, dancing, doing projects at home, entertaining friends, shopping, eating out, cooking together, garage-sale hopping, attending gay-pride marches and a Woman's Weekend festival once a year, and going to church. ¶ RITA: I spend my free time riding my motorcycle—a 1994 Yamaha Virago 535—with Pam riding on the back. I also enjoy driving my 21 Cabin Cruiser boat. I enjoy waterskiing, swimming, and traveling. We both collect postcards and attend shows together. We both enjoy dancing and frequent gay clubs with friends. Pam is teaching me how to golf.

**RITA**
BORN: *December 9, 1943, Passaic, New Jersey*     RESIDENCE: *Hopatcong, New Jersey*     EDUCATION: *R.N. training*     OCCUPATION: *Visiting nurse/home care*     WHEN OUT: *1983*

**PAM**
BORN: *October 1, 1950, Jamaica, New York*     RESIDENCE: *Hopatcong, New Jersey*     EDUCATION: *College two + years*     OCCUPATION: *Pharmacy technician*     WHEN OUT: *1992*

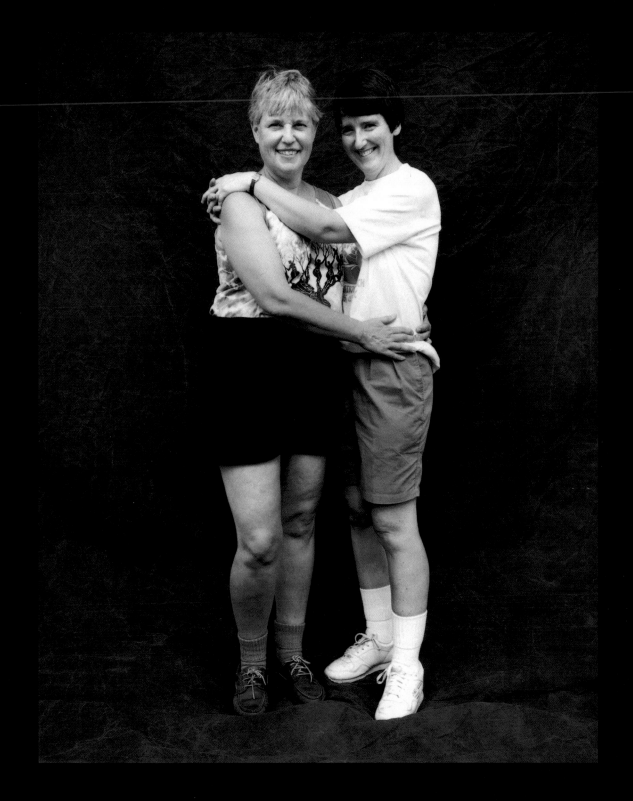

# Leland J. Bard & Will McElhinny

## THIRTEEN YEARS TOGETHER

**How We Met** ¶ LELAND: When I met Will, I was a cook and waiter at a small gay café (Annie Skinners Cafe) in Portland, Oregon. A friend was trying to get us together, so when she came into the café with Will, I immediately questioned her about him. She gave me his phone number and later that evening I called and we arranged to meet. We have been together ever since.

**Coming Out** ¶ LELAND: I started playing around in 1957, and came out of the closet in Greenwich Village in 1963. Coming out to my family was very difficult. I came out to them in the early 1970s. I waited until I completed my tour of duty in Da Nang, Vietnam (1968–1969) and the United States Navy in 1970. They took it very hard, and deep down I think that they blamed themselves. They are now very aware that it was wrong to think that way. No one was to blame for my sexual orientation, I was born gay. My relationship with my parents is very close and loving. ¶ I have never had a problem coming out to my friends. My friends have always judged me for myself and not by my gayness. My life today is rich with loving and caring friends—more heterosexual than homosexual. ¶ My job performance has never been hampered because I am a gay man. I have never hidden my sexual preference from anyone. But on the other hand, I have always been able to separate my personal life from my professional career. ¶ Being raised a Roman Catholic was quite a strain on me and coming out. As I started understanding my sexual preference, and the church's views against the life-style that I chose, I felt that it was better to drop the church. Even though I believe that there is a greater being, Mother Nature has supplied the best church—to talk or pray. ¶ WILL: Coming out has had a very positive effect on all aspects of my life. If I were not able to be honest and had to watch every word and movement, I think that life would be very difficult. Being in the closet is not worth it. Coming out to my family was an investment. It wasn't overnight and it wasn't always easy but it was an investment that has paid off. Lee *is* a member of my family. I'm lucky to have such a supportive family. ¶ Being out at work has only a good side. Since everyone knows my story, there's no reason to hide. With this obstacle out of the way, I am able to concentrate on my work. Regarding religion, the Religous Right has absolutely turned me off toward religion. I have never been a very spiritual person. I do, however, believe in Karma. I try to do only good things and to be the best person I can and that is the extent of my spirituality.

**Statement** ¶ LELAND: When we first met, we were both rough gems. Now with thirteen years under our belt, we have become polished precious stones to each other. ¶ WILL: Lee and I make a perfect couple. We complement each other beautifully. We are more than lovers, we are best friends. We are together for life.

**How We Spend Our Free Time** ¶ WILL: We are collectors. We go to all sorts of flea markets and second hand shops. It was through this shopping that I renewed my interest in View Master and discovered the existence of the View Master Personal Stereo Camera, which was manufactured for a short period in the 1950s. I have been using this camera for five years and all of our personal pictures are in 3-D. I laughingly refer to myself as the gay community's 3-D historian. I have documented the 1993 March on Washington, the Queen's Day activities at the homo monument in Amsterdam, and Stonewall 25, all in 3-D. These reels are our history and my legacy to the world. ¶ LELAND: Our activities together have changed many times since we have been together. When we met, my life was built around bars and drinking. That changed overnight since Will didn't drink or smoke. Out of love and respect for Will, bars and drinking are no longer a requirement. ¶ We both enjoy spending time with each other's family. Recently, we have gotten politically involved due to the antigay initiatives.

---

### LELAND

**BORN:** *December 18, 1945, Fort Kent, Maine*   **RESIDENCE:** *Portland, Oregon*   **EDUCATION:** *Twelve years*   **OCCUPATION:** *Chef*
**WHEN OUT:** *1963, in Greenwich Village*

### WILL

**BORN:** *October 14, 1956, Oregon*   **RESIDENCE:** *Portland, Oregon*   **EDUCATION:** *Two years of college*   **OCCUPATION:** *Payroll clerk*   **WHEN OUT:** *1978*

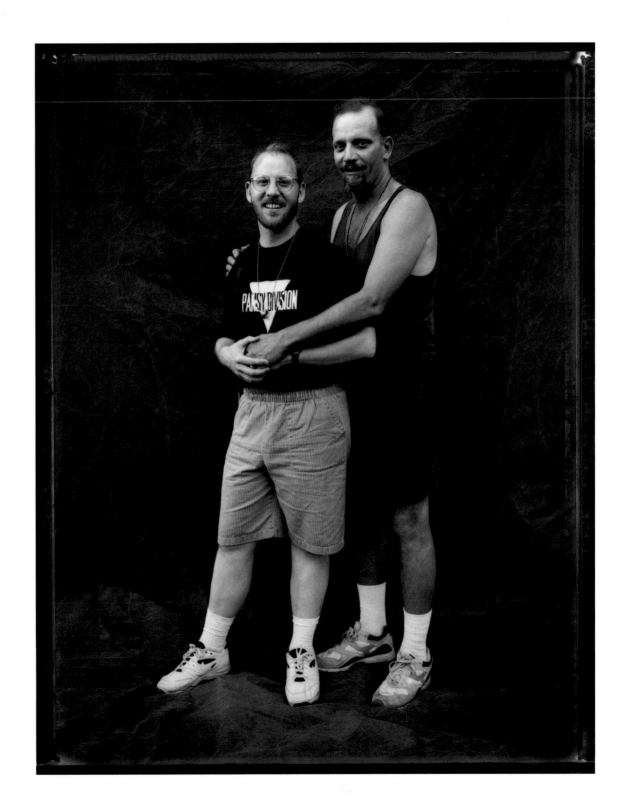

# Katheryn Lumgair & Kathryn Snider

## ONE AND A HALF YEARS TOGETHER

*How We Met* ¶ Playing volleyball, preparing for the Gay Games of 1994.

*Statement* ¶ Katheryn and I were strolling down the road one day, two-stepping in our heads, while our queerly similar voices resounded off the trees. We arrived at the 7-11 and obtained our respective Slurpees—Coke for her and "swamp-water" for me. We looked at each other and knew that if we sweet-talked the counter-girl, the collection cups would be ours for free. You know you've found someone really special when you share these sort of intimacies. Things blossomed from there, and a year and a half later, me at the computer and her dancing around the loft (obviously in the mood to polka), I think we'll plan an older lesbian retreat, knowing that whatever passes our way we'll be friends till the cows come home.

*Coming Out* ¶ KATHRYN S.: Coming out taught me to evaluate risk. ¶ KATHERYN L.: More important than what I learned about myself, I learned about the attitude of others.

*How We Spend Our Free Time* ¶ KATHRYN S.: Two-stepping, windsurfing, playing the flute. ¶ KATHERYN L.: Two-stepping, curling, and designing and producing gay regalia.

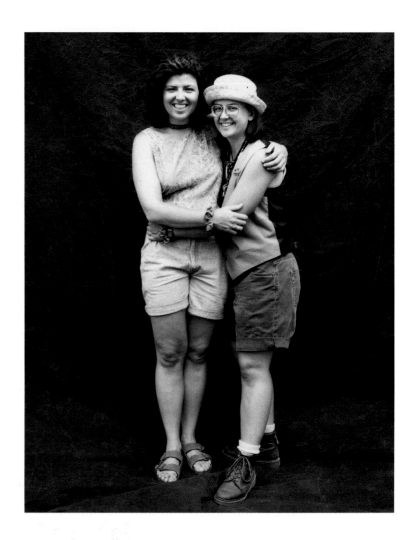

**KATHERYN (LUMGAIR)**

**BORN:** *September 5, 1967, Morden, Manitoba, Canada*  **RESIDENCE:** *Montreal, Quebec, Canada*  **EDUCATION:** *B.A. in progress (Women's Studies)*
**OCCUPATION:** *Student*  **WHEN OUT:** *December 1991*

**KATHRYN (SNIDER)**

**BORN:** *November 18, 1959, Toronto, Ontario, Canada*  **RESIDENCE:** *Montreal, Quebec, Canada*  **EDUCATION:** *B.A., English, M.A., Philosophy, Ph.D. in progress*
**OCCUPATION:** *Student*  **WHEN OUT:** *August 1992*

# Barry Carpenter & Larry Clayton Turner

## ONE YEAR AND TWO MONTHS TOGETHER

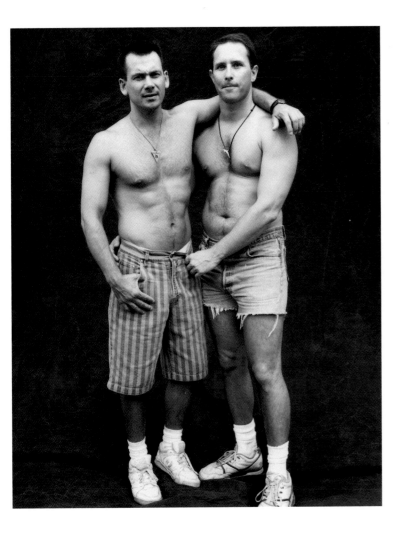

***How We Met*** ¶ BARRY: We met at Ripples, a dance club. Larry wanted to meet me but needed a little help. A mutual acquaintance introduced us.

***Coming Out*** ¶ BARRY: Coming out created a great positive existence, to move out of fear and secrecy into living in the truth. Everyone around me, family and all, is cool. ¶ LARRY: Before coming out I was married for five years, and I have a daughter. I used to practice martial arts and I lived in a small town in Kentucky. Coming out changed everything. My life took on a new direction.

***How We Spend Our Free Time*** ¶ BARRY: I love to travel, scuba dive, plant, lie on the grass looking at the sky, and spend lots of time with my friends. ¶ LARRY: Going to the gym, dancing, and singing.

### BARRY

**BORN:** *August 5, 1960, Los Angeles, California* **RESIDENCE:** *Long Beach, California* **EDUCATION:** *A.A., Accounting* **OCCUPATION:** *President, International Shipping Brokerage* **WHEN OUT:** *Spring, 1983*

### LARRY

**BORN:** *March, 27, 1957, Hazard, Kentucky* **RESIDENCE:** *Long Beach, California* **EDUCATION:** *High School* **OCCUPATION:** *Hair Designer* **WHEN OUT:** *1983*

# Max Gordon & Rufus Muller

## TWO YEARS TOGETHER

***Coming Out*** ❡ MAX: I started coming out in my last year of high school with the support of my friends. The following year in college, I joined a coming-out group and, with its support, began to identify myself as a gay man. For me, coming out isn't something that you do once and get over with, it's a commitment to being visible, no matter if it's a great time to be gay or not. I come out a little bit more every day as I challenge my own homophobia and fear. There are members of my family that haven't accepted my choice to live gay and live out. Part of coming out for me has been creating a new definition of family, made up of those who support me and my relationship. ❡ RUFUS: Coming out was a major initial step in becoming more honest and accepting of myself; it precipitated already dormant conflicts with a few people, and deepened friendships and love with others. As a singer, I face little judgment from colleagues about my sexuality, and have had loving support from most of my family. While coming out highlighted for me the fear and confusion reigning in most "organized" churches on the subject of sexuality, it gave me a much deeper connection with my Christian faith, based as it is on the unconditional love and acceptance of a human God.

***Statement:*** ❡ MAX: Shortly after we met, Rufus would often take my hand or kiss me goodbye in public without glancing around to see who was or wasn't looking. That was very important to me at the time. I figured a relationship between two men was tough love at best; I needed someone to remind me that gay romance is just as vital as straight romance, and that it's fun to get flowers no matter who you are. The magic of being in a relationship with Rufus is that he feels things deeply, like when we go to the movies and he grips my leg because he's moved, or when he enjoys a beautiful piece of music, or a garden, or cooking a good meal. It sounds corny, but when I first kissed him, I felt the room spin. We have our differences. Being a twenty-four-year-old African-American gay male writer living in New York with my thirty-six-year-old English opera-singing lover sometimes feels crazy, and as a man loving another man it gets even crazier. All my issues come up—pride, defensiveness, competition, the father shit. Still, we're committed to being honest with each other at all times, and that, along with laughing our asses off now and then, is what keeps us together. I've found creating a relationship with Rufus to be one of the most challenging accomplishments of my life, one of constant and joyous work. ❡ RUFUS: Max and I are an out, interracial, gay couple. And while this does not define us as perfect lovers who have overcome the homophobia and racism of society—we are society, as much as everybody else, and are learning how to accept ourselves first—we are committed to supporting each other in healing fear through love. We also share a purpose in life to spread that healing through our respective gifts, particularly singing and writing, and through what shows up in our life as a couple. If we can provide inspiration for others struggling with similar obstacles, we shall be adding to the joys we already experience with each other.

***How We Spend Our Free Time*** ❡ MAX: Facilitating workshops, reading, watching movies, and singing. ❡ RUFUS: Going to the opera, theater, cinema, creative workshops, and dancing.

## MAX

**BORN:** *May 19, 1970, Fort Bragg, North Carolina*    **RESIDENCE:** *New York, New York*    **EDUCATION:** *University of Michigan*    **OCCUPATION:** *Writer*
**WHEN OUT:** *Senior in high school*

## RUFUS

**BORN:** *February 5, 1959, Chatham, Kent, England*    **RESIDENCE:** *London, England, and New York, New York*    **EDUCATION:** *Oxford University*
**OCCUPATION:** *Opera singer*    **WHEN OUT:** *Gradually since 1985*

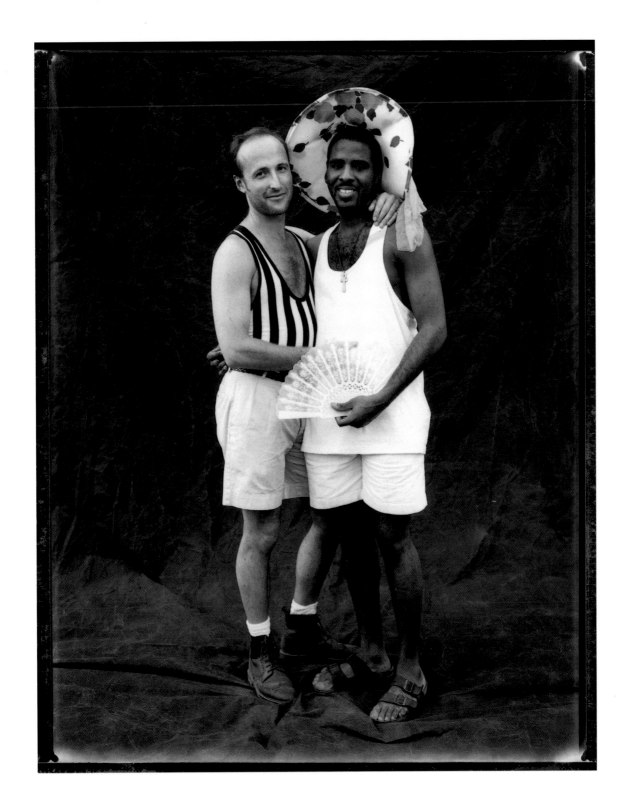

# Kenneth Highton & Dennis Olson

## FOURTEEN YEARS TOGETHER

**Statement** ¶ It's hard to believe that it's been fourteen years since we started dating. We met through a friend of Ken's. One weekend while Ken was visiting his then-boyfriend, Dennis was invited over for drinks on the balcony where everyone was enjoying a beautiful summer evening. Boyfriend or not, Dennis was none too subtle about letting his attraction for Ken be known, and as the "affair" with the boyfriend was on the wane, one thing led to another, and soon Ken was coming to visit Dennis rather frequently. For one entire year we faithfully commuted on alternate weekends to see each other, as Dennis lived in Vancouver, and Ken was still living in Victoria, on Vancouver Island. It was a true test of the depth of the relationship as the journey was tiring at the best of times, involving not only commuting in rush hour traffic, but also a 90-minute ferry trip in each direction. We survived though, and it is with bittersweet memories that we look back on that year. Sweet because of the anticipation of seeing each other once again, and bitter because in two short days we would be separated again. ¶ After much persuasion, including a two-week caribbean cruise (which would be the first of many memorable holidays) Ken finally made the big move to Vancouver in the fall of 1981. It wasn't an easy decision for Ken to make, as not only was he severing family ties, more importantly he was leaving behind a young son just shortly after he had come out. And then there was the question of employment. Somehow we managed, and spent those first years together in Dennis's apartment overlooking English Bay, in the heart of Vancouver's West End, the "Gay Ghetto." ¶ In the meantime, another one of Ken's friends had moved to Vancouver, and, in time his association was to affect us forever. Ray J. became one of the first casualties of the AIDS epidemic in 1984, and although at the time we didn't realize or understand the responsibility it entailed, we were to become Ray's primary care-givers. It was all very new to us then and, in retrospect, if we only knew what we now know, we could have better provided the care he really deserved. Ray's untimely passing was to change our lives, the most dramatic being our move out of the Gay Ghetto and into our own house, due in large part to Ray's benevolence. ¶ Ken had owned houses previously, one with his wife, and a second with his first gay lover. But for Dennis it was a new experience, and it wasn't easy leaving our gorgeous view of the Bay, as well as the many walks we enjoyed along the seawall to Stanley Park. However, we were very fortunate to acquire an older heritage style home in an inner city neighborhood only 10 minutes away from our previous neighborhood, but light years away in attitude. Any early misgivings on Dennis's part were soon dispelled, and our little arts and crafts bungalow has become our pride and joy! We have created a beautiful formal English garden that affords us many hours of therapeutic stress release, and has become our haven from all the anxiety a modern urban lifestyle represents. The care and attention we have invested in making our house not only a heritage treasure, but also our home, has earned us the respect and admiration of many of our straight neighbors. One of our greatest joys is travel, and we have rarely finished one trip before we are planning the next (whether we can afford it or not!). Travel is a high priority for us both, and we are very fortunate that Dennis's employment as a travel counsellor allows us to pursue many holidays. Not only has it broadened our horizons and expanded our vision, but in the process it has earned us some invaluable friendships around the globe. ¶ Our relationship is constantly evolving, and adjustments have been made, some problems resolved (others, unfortunately ignored). But hopefully our love has been strengthened to a point where any obstacle can be overcome. Our greatest strength lies in our compatibility and the common interests we share, while our greatest weakness is our hesitancy to communicate verbally any failings or personal misgivings. One aspect which has greatly enhanced our relationship is the support we have received from friends and family alike. Dennis is particularly fortunate in that he has two gay brothers he can relate to, one of whom he is especially close to, Chris. Chris lives in Montreal with his lover, and like us, has been in a long-term relationship. His other two straight brothers and one sister (a good Catholic family, if it were known) are also very supportive and accepting. It was actu-

### KENNETH HIGHTON

**BORN:** *June 4, 1946, Blackpool, England*   **RESIDENCE:** *Vancouver, British Columbia, Canada*   **EDUCATION:** *Diploma of Technology (Surveying)*
**OCCUPATION:** *Banking*   **WHEN OUT:** *1976*

### DENNIS OLSON

**BORN:** *January 28, 1953, Calgary, Canada*   **RESIDENCE:** *Vancouver, British Columbia, Canada*   **EDUCATION:** *High School Matriculation / College Diploma of Interior Design*   **OCCUPATION:** *Corporate Travel Counselor*   **WHEN OUT:** *1973*

ally through Chris and his circle of friends that Dennis discovered himself and came out of the closet in 1974! ¶ Ken, on the other hand, had a few complications. His coming out had been a total shock and dealt a terrible blow to his family, for he had been raised in a very religious home, and was, at the time, happily married with a new son. While his parents were always very supportive of Ken, they did not condone or understand his new lifestyle, and encouraged him to pursue psychological counselling to "cure" himself. Ken had discovered his true identify however, and in time his family, his only brother, as well as his wife, were all able to come to terms with the situation, and have learned to respect, not just tolerate,our chosen lifestyle. In fact, the love and support that Ken's parents have demonstrated over the years is something special that we will always cherish. Ken's ex-wife eventually re-married and had another son, and along with her husband, have been remarkably understanding and accepting, under the circumstances. Ken's son, whom we have seen grow into a fine young man has only ever really known Ken in a relationship with another man, and although he has also been raised in a very Christian home, has never distanced himself from us at any time. To Ken, he is one of the singularly most important people in his life. ¶ We feel very fortunate indeed to have the love and support of both family and friends who have helped instill in us the mutual respect and love for each other that has been so instrumental in nurturing our relationship. Also, enduring the devastating losses that we have all experienced these past several years of many so close to our hearts, we have hopefully learnt that a loving relationship should never be taken for granted; rather, it should be cherished for all the joy and happiness it can give us every day of our lives.

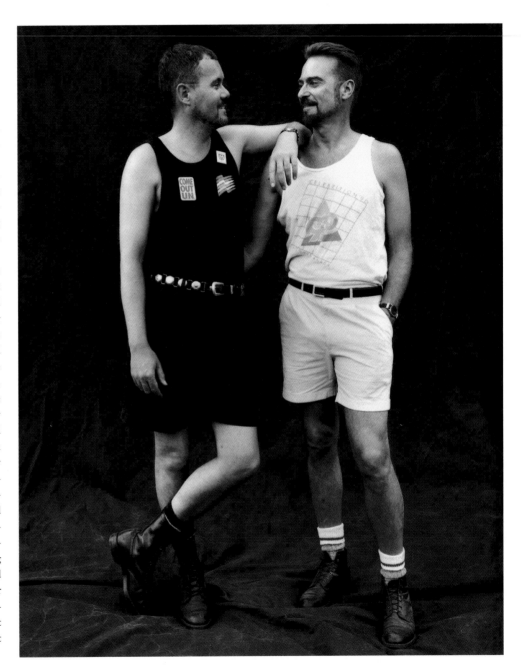

# Danny McCloskey & Jim Patterson

## ONE YEAR TOGETHER

***How We Met*** ❡ JIM: Two years ago, Danny wrote a play based on "Pinocchio" that I coproduced. As the rehearsals progressed, so did our friendship. After the show ended, our relationship took a turn and love blossomed! ❡ DANNY: I had been writing a play that Jimmy was producing and performing in. When we met everything in the room faded to fog, except for the bubble surrounding the moment.

***Coming Out*** ❡ JIM: When I first came out I was very "in your face." I am very proud of who I am, but being raised as a Catholic really created havoc with my inner self. I am now a recovering Catholic and a recovering addict and alcoholic—clean for six years. ❡ DANNY: As a child of the 1960s I had sex with both genders, leaning heavily toward males. I came out and found all aspects of my life, followed the change, and immersed myself immediately in the emerging gay culture.

***Statement*** ❡ JIM: My relationship with Danny amazes me. I have always been so afraid of opening up to a lover—letting him get to know the real me. What if he doesn't like what he sees when he really gets to know me? That hasn't happened at all. Danny is the kindest, most patient and loving man I've ever met. We never fight as we communicate honestly, openly, and willingly. When we first met, the noise around me disappeared and all I saw was Danny standing there. It was like a scene from a movie.

Everything else was in slow motion. I knew this man was for me. Danny has taught me to open my heart and sing. I truly love him. ❡ DANNY: My time with Jimmy has given me insights into myself. As lovers we realize that we are two individuals walking a road side by side, supporting when necessary, taking turns leading and following. We believe in monogamy of the heart. We work and rework the guidelines of our relationship through constant communication. We never fight, but this is not to say we don't disagree. A major rule however, is that we do not go to sleep angry or resentful. I love Jimmy with all my heart and I am continually grateful and excited by the life the fates have provided.

***How We Spend Our Free Time*** ❡ DANNY: Reading, writing, and rhythm. ❡ JIM: I love movies, so we attend a lot of them. I also love to act, sing, and dance. I've never had any high that beats performing in front of an audience!

**DANNY**

**BORN:** *September 2, 1952, Philadelphia, Pennsylvania*   **RESIDENCE:** *San Francisco, California*   **EDUCATION:** *High school*   **OCCUPATION:** *Writer*   **WHEN OUT:** *1970*

**JIM**

**BORN:** *July 23, 1956, Indianapolis, Indiana*   **RESIDENCE:** *San Francisco, California*   **EDUCATION:** *Currently attending University of California, Berkeley*
**OCCUPATION:** *Substance-abuse counselor for 18th Street Services, treating gay, bisexual men and transgenders*   **WHEN OUT:** *1980, with a bang!*

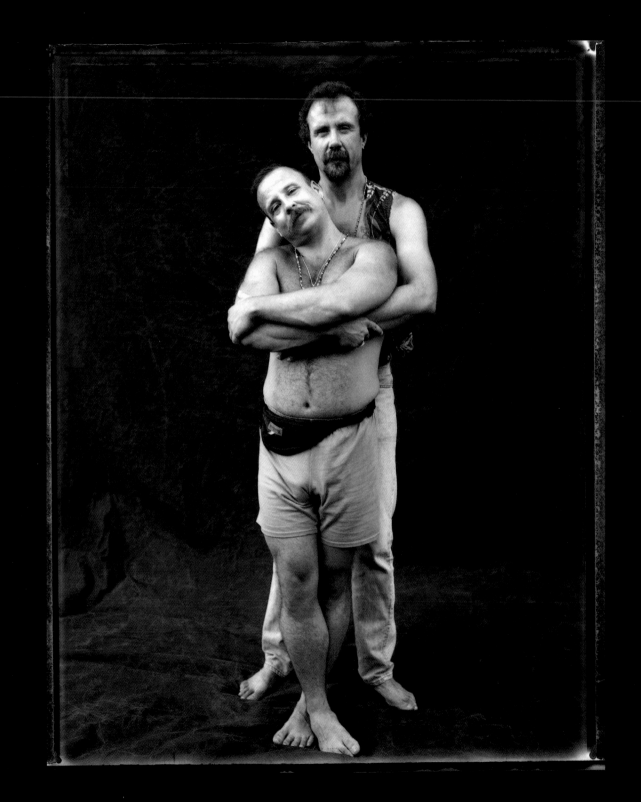

# Debra Cedeno & Karen Stults

## ONE YEAR TOGETHER

*How We Met* ❡ DEBRA: I met Karen about four years ago at a barbecue at my house. One of my housemates invited her and her boyfriend, and most importantly her brand new puppy named Egypt (sweetest little thing). I remember distinctly because my girlfriend at the time also had a dog so I thought she was sweet and that was that. She was "straight." She says she had dinner at my house *subsequent times* and saw me in the 'hood, but I don't remember seeing her again. Until . . . in the fall of 1993, I was going to a "rap group" in the Lesbian Resource Community Center, after my six-year relationship ended. I had only been a few times, and one night she shows up. I'm not sure if I was excited because she was there, looking totally adorable and realizing she was not "straight," or if I was immediately crushed out on her and wondered if the woman she was with was her girlfriend (she was not). I got her number from my old housemate (the one that invited her to the party four years previously) and I called. Nuthin' happened. Oh well. That was in November. About a month later, she called me. We have been together since. ❡ KAREN: Debra and I met four years ago at a barbecue in the neighborhood. We were both in other relationships at the time and didn't take much notice. Seeing her around the neighborhood, I always thought she looked beautiful and untouchable. A little over a year ago, we met again at a rap group in the gay community. We started dating about a month later.

*Coming Out* ❡ DEBRA: The first person I told was my father. He said he knew and still loved me as much as always. My mother, who I had been close to most of my life, said she wished I had not told her. My brother, who was my best friend growing up, wondered if something traumatic in my life had happened to cause me to give up on men and take the "easy way out" with women. My sister was last, who in the last five or six years I became quite close with, and was upset that she was the last to find out but that she was not surprised. That was in 1984. Today, with a few lapses regarding my mother here and there, my entire family has been amazing. They could not be more supportive. I feel truly blessed. Gender is not an issue, this is my lover, this is my life and they have been there for me. Especially surprising was my mom when my lover and I of six years broke up. I love my family with my whole heart. My brother's wife and my sister's husband have also followed suit, they are a part of this incredible support system I call "my family." ❡ KAREN: I am still coming out. I fell in love with a woman for the first time seven years ago. Since then, I have had relationships with both women and men, but I find myself more and more drawn to women and the lesbian community. For the past five years, I have felt privileged to have been completely supported in my job and, more recently, in my growing community of gay (lesbian/ queer/bisexual) friends. Coming out to old friends, to family—and to myself—has been harder. I am still

defining the lifestyle that I want. I carry around the "white picket fence" picture of myself in relation to my family and my future. I need to feel free to paint that picture however and with whoever I want— without feeling the guilt of judgement from family and friends and total strangers who might wish me to do things differently.

*Statement* ❡ DEBRA: In the past year we have traveled a little bit together. She took me home with her on her 30th birthday to Florida and I met most of her family. We travelled and took time off in New York for the Gay Games and Stonewall. We have had weekends in West Virginia, mountain biking and camping, fun beach trips to Rehoboth, and long hikes in the woods with Egypt. I brought her to meet the rest of my family for Thanksgiving this past year and we are planning another vacation this summer on the West Coast! I hope to plan days for drawing, painting and reading together, more rendez- vous' at the local coffee shops (which in DC are plentiful, gay populated, and lots-o-fun) and dancing —which we both love to do (especially together). I love us. I love who I am when I am with her. We en- courage each other's independence and strengths, honesty and openness, dreams and explorations and things that help us grow together as individuals, and as a partnership. ❡ KAREN: This is a very exciting and challenging time in my life. At 30, I have begun to pursue decades-old dreams. I have resigned from

---

### DEBRA

**BORN:** *October 21, 1964, Upper Montclair, New Jersey*   **RESIDENCE:** *Washington, D.C.*   **EDUCATION:** *B.A., Fine Arts, B.A., Architecture*
**OCCUPATION:** *Architect, Self-defense instructor*   **WHEN OUT:** *1981*

### KAREN

**BORN:** *July 22, 1964, Maryland; raised in Florida*   **RESIDENCE:** *Washington, D.C.*   **EDUCATION:** *M.Ed., Public Policy*
**OCCUPATION:** *Organizer and non-profit administrator*

my nonprofit job to pursue an interest in ceramics and clay sculpture. I have started rowing crew. I am beginning to think about settling down—even in the midst of these new beginnings.

***How We Spend Our Free Time*** ❡ KAREN: Taking long walks with my dog in the woods near my home. A weekly dose of solitude and fresh air keeps me sane and helps me to visualize solutions to a host of artistic and logistical questions. I work out occasionally at a gym, spend as much time as I can with friends and like to read great fiction. Between Debra's karate, my art and earning a living, there isn't much free time to share. We like to meet in the community for tea or dancing, take hikes in the surroundings woods, stay in bed late. I am hoping that as I get more immersed in the arts community there will be new people and events to share.

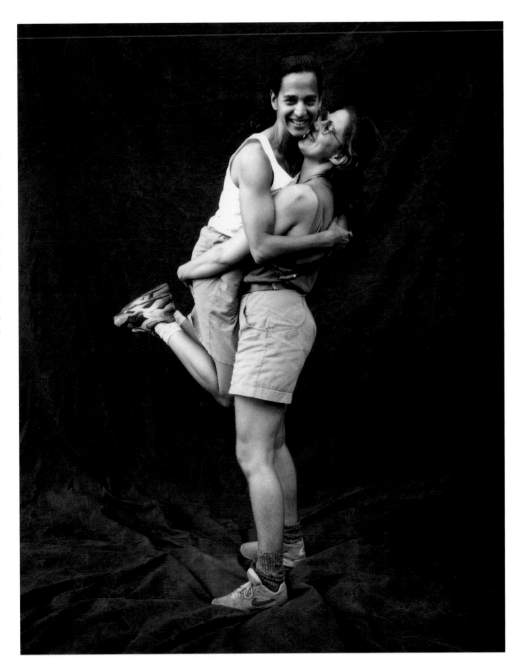

# *Afterword*

## QUENTIN CRISP

Love is a four-letter word.

I never use it, and I'm happy to say that it has never been spoken to me by a man. But *Couples,* with the very minimum of sentimentality, is almost a testament of L——e, and it will be, for many readers, both gay and straight, an encouraging experience.

But in modern life, nothing is eternal—certainly not love. Where there is no hope of alimony—no reward for fickleness—a union may last a little longer. That is why marriage among the poor tends to survive the test of time and marriage among the rich does not. Its absence may also be a reason why relationships among gay men are usually of such short duration, though with the further impact of *palimony* decisions, "alternative marriage" may become as ephemeral as heterosexual marriage.

Some of the couples described in this book have been together for more than a decade. But there is no mention of how "open" these relationships may be. There is not even any slightly pornographic passage describing the nature of the sexual practices the couples agreed upon.

It is also interesting that in most cases each partner describes the moment and the nature of his "coming out." This is important because with most of us the statement of our sexual orientation takes place in a void, as it were. Some strange life-style is conjured up in the mind of the person to whom we confess our sin, but when a son, for instance, stands before his parents beside his "true love" and explains that their relationship is sexual, the matter has to be taken seriously. It raises practical issues. When the son

pays a visit to his parents' house accompanied by his "friend," are they both placed in the same bedroom? Is their sin condoned? This is a question that in her book on excruciatingly correct behavior even Miss Martin does not answer, though she does say that on occasion it is wiser to arrange a buffet supper rather than a sit-down dinner where the sexes (assuming there are only two) are placed alternately.

Oddly enough it seems to have been the mothers who reacted most strongly against the news that there was kinkiness in the family. As a rule mother's only reply is "Don't tell your father!" and, since fathers and sons usually sustain a distant relationship, any disruption to it is hardly noticeable whereas the bond between a mother and her son goes deep and suffers a major trauma if for any reason it is broken.

This is a worthwhile book because it highlights the cozy, domestic aspects of homosexuality rather than some bizarre and frightening qualities that other works on the subject present. But it makes little mention of "gay marriage," which many enthusiasts currently insist upon (to the dismay of some heterosexuals who consider marriage a sacrament, and are outraged by its being offered to couples whom they consider to be sinners of the worst kind). In general there is very little complaint in these pages about the world's treatment of its outsiders, which is a relief.

The discussions in these pieces are refreshingly honest and revealing. If I have any regret when reading *Couples* it stems from the fact that nowhere does any of its subjects explain or even hint at why he or

she found it necessary to form a lasting relationship. It always seemed to me to be one of the charms of homosexual life that nobody need get stuck with somebody because to part from him or her was such a chore. The sharing of property and a place to live, the burdens of distasteful monotony, did not enter into the situation. This meant that one made love to somebody while one still liked him, which is such a rarity in normal life.